An Alien Odyssey to Creative Freedom:

nothing

Towards a Theory of Artistic Research; from the Abstract Maybe to the Concrete Real

nothing

Brendan Michal Heshka

nothing

Contents

Introduction to the Premise

I
"If we could communicate, we wouldn't have to."

Toying with the Tyranny of Meaning; Considering the Parallels in the Discourses of Art, Psychoanalysis, and Text

II
"Art is dead, long live art."

Art as Revolution, Escaping the Jail of the White Cube and the Stranglehold of Art History

III
"Good Work," he said and went out the door. What work? We never saw him before. There was no door."

Nothing is Better Than Nothing, Enjoying the Vacuum

IV
"It is dreams that constantly remind us of freedom—there is no other source. Dreams give us impulse to distrust all necessity, to despise the iron rule of the status quo. In dreams I have tasted blood. Dreaming, I become aware of possibilities that reality denies me over and over again."

Techniques to Finding Mass in the Void;
Dreams, Boredom, Violence, Interacting Forms, Symbols & Signs, Death.

V
"I create because I know how.
I know how good-for-nothing I am, that is.
Art as communication, is the contact between the good-for-nothing in one and the good-for-nothing in others.
Art, as creation, is easy in the same sense as being god is easy. God is your perfect good-for-nothing."

The Artwork

VI
Conclusion:
Pure Poetry & Love

..

nothing

Premise

Imagine

nothing

June 29th, 2015. New York City, USA.

A successful independent curator is invited to organize a group exhibition at a prominent gallery in New York City, the MOMA. The Curator selects from a wide range of international artists to include in the show. The exhibition is made up of a survey of some of the most important and iconic works of the twentieth century, as well as many lesser-known, more obscure works from the same modern era, while the greatest breadth of works are culled from established contemporary, emerging and even outsider artists working today. The exhibition spans throughout numerous spaces, galleries and even buildings and is heralded as a masterpiece.

The show is a huge success. It will eventually travel to the Tate Modern in London, the Hamburger Banhof in Berlin, the Centre Georges Pompidou in Paris, The Museum of Contemporary Art Barcelona, the Stedelijk in Amsterdam, and finally to MOCA in Los Angeles. Many, if not all the artists (agents, galleries) included, enjoy prosperity in their critical and commercial success. One of the most pleasing elements for the organizers of the exhibition is how the show has been experienced across a broad demographic; the show is well received and attended by a spectrum of audiences. In discussion the curator, her assistants, the directors, and artists all congratulate each other on "reaching a public well beyond the specialist artworld."

Easy to imagine. Is this the present-day story of art?

Exterior. Manhattan Island, New York City. Birds eye view circling above. The buildings are illuminated in the magic hour light as the sun sets into the Hudson River. One particular window, high up in a residential skyscraper glistens, reflects and refracts the last of the natural light. From the wide view of the metropolitan island we zoom in closer and closer to this specific window, closer and closer, now even closer, and closer, on this one particular, glimmering window. As we get closer, and closer, we see that this particular twinkling, is actually a large bay window, it has a human scale and is actually two windows, both of which are vaulted wide open. Closer, and still closer, the silhouette of a figure can now be seen, standing in the twilight, perched on this small, but modernly grand balcony.

The Curator is having a glass of white wine, a perfect Condrieu from La Fondrèche Domaine, Provence, in an oversized glass, enjoying the sunset and the last of the warm summer air. She stands alone but in a split second and with a small burst of energy is joined by another silhouette. The silhouette introduces itself to the Curator as the Alien. The two hit it off quite well and the Curator welcomes the Alien to continue their introductions inside the apartment. As the Curator tells the Alien more and more about herself and her work, the Alien reveals that he is from a distant galaxy and "his culture knows no art to speak of." The Alien desires to understand and know the brocard operatives that preside over earth-artists and the Curator happily offers to be the docent to guide the Alien towards an understanding of art. The entrepreneurial Curator sees an opportunity to make an exhibition like no other before, and invites the alien to "show some work" to the Earth-public, Earth-artists and collectors of Earth-art.[1]

Curator

We will first visit the Met, then the MOMA, the Guggenheim, and then off to the project spaces and commercial galleries in Chelsea. I'll introduce you to David Zwirner and Larry Gagosian and we'll take long lunches over the catalogues and have a look at the writing.

The Alien shares in the Curators enthusiasm and delights in their meeting, his curiosity has led him across space and time and is pleased to be so well received and to have purposeful work to engage in while on Earth.

The following text will unfold by examining in depth the potentiality of the preceding scenario, its purpose, to pin down "what art is," naturally its failure imminent. The journey of the Alien, the Curator and yet to be introduced, the Psychoanalyst is to realize, between them, a concrete definition of art, realizing that the very nature of art, its refusal to be pinned down, resists the possibilities of a universal definition. Using art theory, history and philosophy to deconstruct itself, art becomes nothing/ everything. The void. The necessary empty nothing for any new 'thing' to be created, the space of the artist, a place outside the hegemony of the artworld system that governs him/her. Imagine the void that would be created in our cultural landscapes by cutting out the museums and galleries and theatres...

The goal, to cut away from the history and theory that governs art and artists by using that very theory to free itself. To de-construct, to enter the void and to emerge, to re-construct new possibilities, new starting points, new methods, for making art, and to emancipate art from the ruling regimes of creation.

From the abstract maybe, to concrete reality.

Towards a theory of artistic research.

An alien odyssey to creative freedom.

..

nothing

Charachters

THE CURATOR – MARY:
Possesses and applies a thorough knowledge of art, in theory and practice. The specialist, the one that is supposed to know. An insider to the artworld. Post modern.

THE ALIEN – MYZERITTEUS MÊTIS:
The ultimate outsider. Art's intelligent yet naive anthropologist, whose culture has no art to speak of. A curious figure and the world's first non-Earth artist or not-artist.

THE PSYCHOANALYST:
The listener who mediates and guides the Curator/analysand through analyses. In the position to see the whole picture, occupying the role of observer. Not a specialist in the discourse of the artworld but a specialist in social discourse.

Toying with the Tyranny of Meaning; Considering the Parallels in the Discourses of Art, Psychoanalysis, and Text

I

"If we could communicate, we
wouldn't have to"[2]
—Avital Ronnell

We *find ourselves in an interior, an office in New York City. An exemplary modernist workspace. Eames lounge chairs with Knoll furnishings, a nicely worn-in leather LeBambole sofa. A collection of healthy green plants are sparsely distributed throughout. The walls are curated with formalist paintings and a selection of abstract photographs and artfully rendered landscapes. A nice balance of blacks and whites, colors, furnishings and negative space. The strongest attractive feature is the view, the large windows present a vista that ceaselessly tempts the gaze. Two characters, a man (the Analyst) and a woman (Mary, the Curator), situate themselves to share the outlook. The man sits with a rigid, attentive posture, smartly dressed with a grey suit and tie, a conservative and slick 1950's weatherman's haircut. The only thing that throws of his relatively plain appearance are his rounded tortoiseshell eyeglasses, giving him a touch of eccentricity. The women is less composed, although much more striking in appearance. She somehow seems to have the stage within the room, her posture and plush seating suggests a more relaxed lounge than her counterpart, but her slight recline is tense and strained and she is not as comfortable as her perch suggests. The two sit in a silence that is shared but experienced in entirely different ways, comfortable, attentive and anticipatory contrasted by nervousness, apprehension, and feverishness, a tension that charges the room with potential.*

Analyst

So.

SCENE 2

Curator

Yes, I thought about not showing up at all today.

Analyst

Hmmm. Why do you think that is?

Curator

Uhhhg. There's so much work to do and things aren't really going the way I (*pause*) thought they would.

Analyst

(*silence, a raised eyebrow*)

Curator

I don't know. I mean. I guess I'm frustrated about my work with Myzeritteus Mêtis, I expected—

Analyst

You're referring to the alien that you met and spoke of last time, Myzeritteus Mêtis is his name?

Curator

Yeah, I mean yes that's his name, or at least that's how he is identified.

(*long pause*)

Analyst

Sorry, mmm, before I interrupted. You were saying you expected ...

(*pause*)

Curator

Yeah, I guess I expected because of his exceptionally advanced level of intelligence and—I don't know, maybe even his obsessive curiosity that ...

(*pause*)

I just don't know if this show is going to work out, this whole thing is stupid. A farce.

(<u>*silence*</u>)

Analyst

(<u>*clearing his throat, followed by a long pause*</u>)

Myzeritteus Mêtis is intensely curious and because of his intelligence you thought ... ?

The Curator strains in thought. Resisting free association. Processing.

Curator

I mean—

She can't seem to let go and vocalize her thoughts.

Analyst

Hmmm. you mean?

Curator

I mean. I don't know. I guess I want to understand and to be understood. What the hell is success anyway. I really want to relate to people, to relate what I do and what I love, and what I love to do. But. So often I feel, or, actually, think its all bullshit, it's a game, that I'm, I dunno, not a fraud, but maybe... My position as this dictator. Dictating meaning, dictating value, taking art and commodifying it. Employing this art history canon to make judgment. Who's in and who's out. What's in and what's out? How did I get here? What forces have installed me in this power position that everything must pass through. I'm stuck in this paradox. I'm trying to work out where I stand and how I can actually stand there. I'm capitalizing on this moment. This alien proto-artist comes to me. This ultimate outsider, neo-artist. This kind of pure curious and creative figure between human and nature. A subject that provides a concrete break between the Kantian division of the world of nature and the world of

man. It's so interesting and important and what am I doing? Am I pushing this moment into the commercial, finding a stage for this research in art's galleries and institutions? Capitalizing on this to produce unique commodities, of literally astronomical value. Feeding this collecting fetishism with the ultimate wares. But on the other hand I know this work is important, and that it's true and beautiful and fascinating. Where and how can we work? On this art.

I don't want to sound romantic, but in my heart, there is this feeling. I'm not sure how to proceed. I get, moments, moments of truth where I know. Where is the space for this kind of work? How can I fund our research? What will we produce? Making...

Analyst

You mentioned moments. Moments where you know, moments where this significant doubt you speak of is no longer present.

The Curator gazes out the window beyond the large swaying elms, tracing their green canopies across the blue and silver background of the sky and skyline. No one could know what she is thinking. The Analyst gazes, unmet, at the Curator, listening actively to the nothing, observing the gap in her discourse. In the analysis there is no imagination as to what she may be thinking. While the conversation may appear exactly the same or even far less dynamic than a normal dialogue many

subtle techniques are employed to form the symbolic space for analytic discourse, quite different from normal interpersonal dialogue. "Our usual way of listening is highly narcissistic and self centered, we relate everything other people tell us to ourselves." [3] *We weigh the stories and experiences of the other against our own and try to relate to the way they must be feeling by imagining the way we felt in similar scenarios or situations from our own lives. If we can't relate our own narratives to that of the other's, they seem strange or impossible. When we employ the imaginary, we can only imagine and interpret the silences in the discourse of the other in the terms of any of our own possible thoughts or feeling during that silence, and negate the important differences between every unique individual. This is what Lacan refers to as the imaginary dimension of experience. "The listener is constantly comparing and contrasting the other with herself and constantly sizing up the other's discourse in terms of the kind of image it reflects back," "The imaginary dimension concerns images-our own self-image".*

Curator

I know you must be thinking. What's the point in all this? Why does it even matter? Why even bother? What's the point to even discuss art in depth here? Maybe I should just introduce Myzeritteus to the sciences.

The analyst twists his face into a perplexed grimace and displays his genuine surprise towards the analysand's conclusion.

> *We imagine we understand each other and, in so doing, we are invariably carried off by this imagining. We bring our imagining to the speech we hear, the text we read, the discourse we engage in. We imagine that what we hear or read, what we consume caries a meaning and we imagine that we grasp what this meaning is, imagining that this meaning is the same for each of us involved. Even here as you read my words, I imagine I am saying something to you and I imagine, or even hope, you might understand at least something of what I am trying to say. You, on the other hand, perhaps imagine you have understood something of what I have written. Or at least imagine you do.*

> And to imagine that all these imaginings are pinned to the same thing, well that seems a lot to imagine. I imagine rather that there are so many coloured butterflies, fluttering out of focus and disappearing in disparate directions.[5]
> - Dr Calum Neill, 2012

The Psychoanalyst listens differently.

The Curator paints a portrait of her life, but will always leave out important details and often fail to have the perspective needed to see the whole painting that is her life. The Analysts attempts to fill in the gaps in the Curator's discourse; it is his job to see the whole picture[6].

The Curator (analysand) and the Analyst do not work face to face. Much like the painter and the spectator, who gazes at the painting[7], or the author of a text and its reader. Here we have a parallel between the discourse of psychoanalysis and the discourse of art and the discourse of text (spoken or written). In Psychoanalysis, although a milieu is shared, the analyst and the analysand literally don't work face to face, abetted by the couch/chair asymmetry and by the use of other numerous techniques their work is not an exchange of mutual benefit, both look, see, hear and experience on different planes. The analysand gaze is directed elsewhere, summoning her unconsciousness through the free associations of the uninhibited telling of her story (or the painting of her picture) and by looking attentively into her dreams and fantasies. The analyst's gaze is directed in the direction of the analysand but they do not meet, he, much like the analysand, is not looking at that which sits before him, but looks for what is not there. The gaps in the story, the slips of the tongue, the gestures and shiftings, unfinished statements, the narratives of past sessions and many other elements that help him see the whole picture. The analysand works to explain, justify, give meaning to, and present a narrative of ones life for the analyst to understand them, the way they themselves do. To believe that this is the real work—the understanding—and that this work may even be possible is an illusion.

Painting runs parallel to psychoanalysis. "Both the psychoanalytic session and the painting preclude reciprocity between two parties," any comprehension must always pass through the work. "The painter[8] invests the painting with an aura of its own but the gaze of the painter and the viewer never meet"[9]. The artist's work embodies meaning, born through her subjective philosophies, knowledge, passions, awareness and unconsciousness. She works for expression of these subjective elements but her work also seeks to be understood, for the meaning compressed into her work

SCENE 2

to perforate and bloom into the world, as truths. She wishes to communicate something inherent within herself outwards to be grasped by the other and the whole of the others, reality. To strive for this artistic communication is to pursue failure, the painter and the spectator can never see eye to eye. To believe that the real work in the session, or the artwork or the text is to be understood is to be mistaken.

The author and the reader can never meet. "To restore writing its future, we must reverse its myth: the birth of the reader must be ransomed by the death of the Author."[10] Meaning is not born in the writing of a text but in its reading. Reading/analyses/viewing art, is a creative process. It is a delusion to believe that reading (analysis/art) might produce anything objective. "To assume to access an objective plane which somehow transcends our investment or identification in the text is to deny what we do. ... We cannot put ourselves out of our reading and to pretend that we can is, well, to pretend. To consume is to identify."[11] The meaning is always my meaning, not that of the author.

"You never look at me from the place which I see you."[12]

CUT TO:

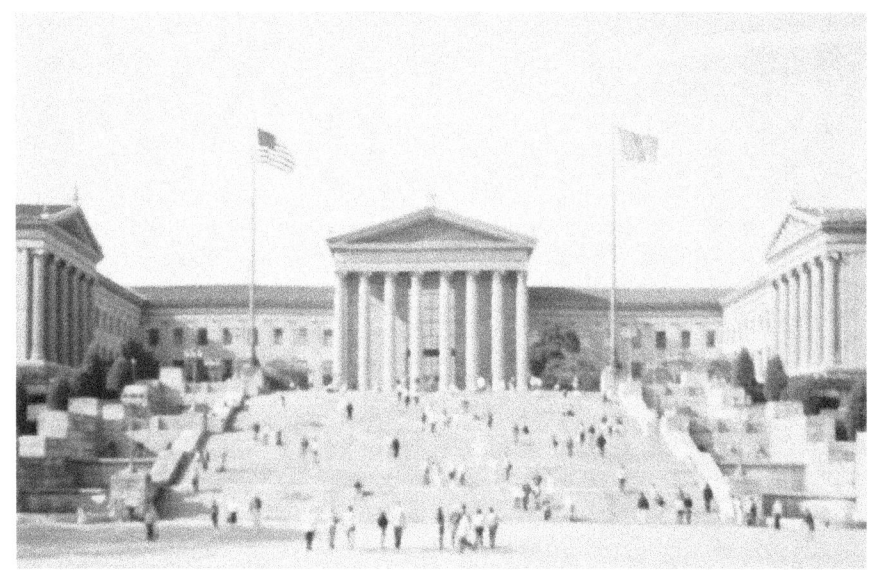
Rocky steps to dada Dada

The Alien emanates up the grand staircase of the Philadelphia Museum of Art, ignored and surrounded by people running the 'RockySteps' and taking pictures of themselves and one another. Through the beautiful Cy Twombly collection and into the chambre Duchamp. The Readymades; the Bicycle Wheel, the Bottle Rack, the Comb and the Fountain. The Alien has the ability to directly address Marcel Duchamp through the object of his works, a generic trait possessed by his entire race, psychometry, the capacity to communicate through objects, a quality that could explain why Myzeritteus' culture has no (necessity for) art as we know it. Earth Art requires an element of incompleteness, a certain mysterious element that engages the spectator to create and imagine its possible meanings, to generate a kind of feeling and learning process where something significant is found in the exchange[13]. A discovery that while it might not necessarily be able to be expressed in language, completes the art and an objects 'artness'. Through Myzeritteus' psychometry, the object reveals itself in totality, its history, its use, its significance, etc., through contact with a kind of energy field that emanates from itself, akin to a type of perfect memory and knowledge contained in its materiality. This ability and reception fundamentally changes art. Doesn't it?

Alien

I see what happens here. An ordinary object is redeemed of its functionality while simultaneously an object in the museum is redeemed from artistic toil.[14] This thing called *Art* can be materialized as anything, it's freed from an act of labor and/or a skillful act born of talent and training. It doesn't need to be made, it can be thought of, it seems here that although the work still appears as a tangible object the real work of art is the idea, embodied by the object. The preexisting thing is taken and placed in an art context. The context, the museum, the gallery, the stage, etc., is what makes it art.

Duchamp

Bon, Oui. But we must also consider another important factor, the two poles of the creation of art: The artist on the one hand, and on the other the spectator who later becomes the posterity.[15]

Alien

It's as though, to all appearances, the artist acts like a mediumistic being who, from the labyrinth beyond time and space, seeks his way out to a clearing... The phenomenon is comparable to a transference from the artist to the spectator in the form of an esthetic osmosis taking place through the inert matter, such as pigment, piano or marble.

Duchamp

In the creative act, the artist goes from intention to realization through a chain of totally subjective reactions. His struggle toward the realization is a series of efforts, pains, satisfaction, refusals, decisions, which also cannot and must not be fully self-conscious, at least on the esthetic plane.

Alien

And the result of this struggle is a difference

between the intention and its realization, a difference which the artist is not aware of.

Duchamp

Consequently, in the chain of reactions accompanying the creative act, a link is missing. This gap, representing the inability of the artist to express fully his intention, this difference between what he intended to realize and did realize, is the personal 'art coefficient' contained in the work... The creative act takes another aspect when the spectator experiences the phenomenon of transmutation: through the change from inert matter into a work of art, an actual transubstantiation has taken place, and the role of the spectator is to determine the weight of the work on the esthetic scale.

Alien

So, all in all, the creative act is not performed by the artist alone; the spectator brings the work in contact with the external world by deciphering and interpreting its inner qualifications and thus adds his contribution to the creative act.

Duchamp

Exactly, (*laughter*), well I should say more or less.

And this becomes even more obvious when posterity gives a final verdict and sometimes rehabilitates forgotten artists... Art history has consistently decided upon the virtues of a work of art through considerations completely divorced from the rationalized explanations of the artist.[16]

Alien

Ok.

I understand *(pausing and panning across the Readymades and other works in the small gallery chamber)*. But I would like to interrogate further a term that you have used often here, esthetic or aesthetic.

Duchamp

ah bon, oui, nous y allons. There is "a point which I want very much to establish, that the choice of these Readymades was never dictated by esthetic delectation. This choice was based on a reaction of visual indifference with at the same time a total absence of good or bad taste—in fact a complete anesthesia."[17]

Alien

I think it's important to "see just how radical a [belief it is] that art, in and for itself should

have a tangible quality, which is only realized through its specific instances. That it is something different from the product of cognitive knowledge"[18], that is to say I find it extreme to view art as a priori something material with a dimensional physicality. I would like to turn the contemporary usage of the term 'aesthetic' on its head, "from representing something rather cosmetic and superficial"[19], beyond a concern with beauty and formalism. "The formulation of 'the aesthetic' takes its roots originating as the opposite of 'anaesthetic' or numbness. From this perspective, aesthetic comes to mean 'enlivened being'" and becomes linked "to responsibility, not as a moral imperative, but to response—ability, or the ability to respond"![20] So 'the aesthetic' of the artwork cannot refer only to how something is perceived formally in regard to taste or beauty but on how it overcomes a numbness and engages us in an enlivened state of being, to cause one to enter an internal creative state, to mobilize 'our' imaginations. The second hand in the making of art that you referred to.

Duchamp

Nice, I appreciate the etymologic clarification

and opening up of the term. And would agree that it does seem radical to assume the creative act would require a material form. Of course a catalyzing gesture that overcomes the numbness of another towards an enlivened sense of being could transcend materiality, and it would be hard to argue that it isn't art. "Peut-on faire des œuvres qui ne soient pas d'art'?"[21] Je sais pas? "You see, I don't want to be pinned down to any position. My position is the lack of a position."[22]

Alien
There's no solution, because there's no problem.

Staring into, across and through Duchamp's large glass, **The Bride Stripped Bare by Her Bachelors** *we slowly fade back into the Analyst's office.*

CUT TO:

The Curator is comfortably reclined with her feet up on the matching ottoman, shifted almost entirely towards the windows that frame her, her face is relaxed and her eyes are glazed in a state of uninhibited free associations. She speaks her mind.

Curator

Maybe all this work to make meanings is erroneous. It's clearly only a course to failure. To believe differently is delusional. This must be accepted to go on working.

There are actually many layers to a work of art. I think you could compare it to the divisions that we accept proposed by Freud, with the unconscious and the conscious, and the Id, the Ego and the Super Ego. Like ok, I'm not necessarily trying to get rid of meaning but maybe the transmission of subjective meanings, into some kind of unified empirical reading of a work. It denies us our uniqueness and fundamental human differences, and refuses us the creative act of reading. Its all very cerebral, what about the sensual or the bodily or what else... I want to consider the 'what else'!

What else is happening? This layer of meaning is a social construction, fed and fueled by knowledge and history and education, it can actually be

very limiting. It is but a single plane, which is actually anything but singular. A very conscious layer, "what is beyond the mask of intellect[23]"? What else is happening in the work of art? What happens in the muck below this layer of meanings where forms simply interact, it can't be denied that this plane must also exist.

It's like the fundamental argument concerning the creation of the universe, God versus science. Is there a singular omnipotent, meaningful point of creation, God? Or does creation come from a cosmic imbalance, a kind of prodigious catastrophe, that things exist by mistake, caused by the collisions of forms, some fragments some vanishing things. Particular things begin to appear when the balance of emptiness or space is disturbed.[24] If God is dead, does that mean the artist is dead?

Analyst
You feel that to continue to pursue an art making that strives for the creation of meanings would become falsely contradictory and irreconcilable for you?

Curator
I'm interested in the muck below the layer of meaning.

Analyst

Hmmm, the muck below.

Curator

Ok, there's something in all this, with symbols.
(*Long pause*)

Maybe the 'symbol' stands in for these particles that collide and react and form a creation.
(*Pause*)

Ok... I'm thinking of traditional celebrations. So a pine tree is a symbol for Christmas, the Christmas tree, it means Christmas, a pumpkin is a symbol for Halloween, a rose would symbolize Valentines Day. So imagine the artwork as a kind of garden where these symbols begin to come together and traverse their expected calendar appearance. "What happens when the roses cross the pumpkins? We would have a potential new sign for a celebration, yet empty of meaning."[25] The thing itself is empty of meaning, from its creation.

We encounter it. Not as a passive audience, in the character of being audience, subject to the artist. We are witness. We become apart of the myth, more easily. It's a "zone of non-knowledge."[26]

Garden of Colliding Symbols

SCENE 4

Its even unclear what it means to be witness to this unusual garden of colliding symbols? It's an open system. "The witness sees the encounter, (say) of two cars that create an accident. Eventually someone would ask you; 'what did you see?' You experience without any preset, an encounter that you can report on", "which can be translated into your experience in a subjective way."[27]

It's another plane. It frees us from our outside position, gazing at an artwork in a contemplative, hyper-conscious state; we become a part of the picture.

Analyst

Lacan speaks about certain powers of the picture that feed on the voracity of the eye and desire of the gaze, the most exemplary, *invidia*, in Latin, is the sense of envy, a 'looking upon' associated with the evil eye, there is no mention of a good eye anywhere, 'to look against'. He uses the example, of Augustine, "in which he sums up his entire fate, namely, that of the little child seeing his brother at his mother's breast, looking at him *amare conspetu*, with a bitter look, which seems to tear him to pieces and has on himself the effect of a poison."[28] We seek to tame the gaze with possession.

You're suggesting that with this sort of dispersion of meaning towards a kind of experiential garden of symbols, we are finally allowed our position to enjoy the milk from the breast. Satisfying.

It seems, on another level here, this type of artwork, frees itself from the fetishisation of the collector who must posses, and the play of audience as the one who wishes to posses what they gaze upon, the fundamental driver of the art market in the capitalist model.

Curator

Ahhhh. Ok. I guess so.

Mary, the Curator pulls herself out of the trance of her free associations. She props herself into a sharper posture and attends to what she has put forward.

Curator(continues)

Yes actually. It makes sense. I guess maybe that does some up what I'm saying. And how I feel, and why I'm frustrated inside this other, ruling system.

Analyst

You made the statement that God is dead and put it in connection to another statement, the death of the artist. Are you sincere, is this your belief?

Curator

Well. Ummm. Ahhh...

Analyst

You are trying to do away with this idea of a fascistic subjective meaning that is allowed to preside over the artwork. Whether put in place by the artist herself, in conjunction with the cannon of art history, or some art specialist or by some omnipotent didactic text that accompanies the work, that tells what it is.

(*Pause*)

You are looking for an emancipation from this tyranny of meanings?

The Curator laughs a little and nods with a relieved and relaxed air, but the Analyst holds sternly, straight-faced, maintaining his questioning. The two look at each other and speak face to face.

Curator

Yes, ok, I think its true, maybe that's what I'm fighting against without knowing it and why its been unattainable for me to be satisfied. But where does that leave me now? And my work?

Analyst

Well, to me it doesn't sound like the death of 'some thing', more like the birth of some 'other thing', or re-birth. An opening up of new possibilities for your work. Its not that there simply is no truth to this language and anything means whatever you want it to, but that truth must be fought for, there are innumerable meanings and the point is to engage in this struggle.[29]

Curator

Yes.

The Curator shifts back towards the view and searches the empty sky, falling back into her thoughts, filling in this new empty space of discovery with possibilities and questions.

Curator (continues)

What do you think?

Analyst

I think it is quite interesting to take the idea of God as creator and use it as a metaphor to explore the artist as creator.

Curator

Actually? I think that's quite boring as a metaphor.

SCENE 4

Analyst

You mentioned God up against science but within your atheism, and following the threads you've been describing, I also hear the underpinnings of Christianity. A philosopher colleague of mine makes the argument that "the message of Christianity here is radically atheist."[30] We get a lack of meaning when Christ dies on the cross.

Curator

A lack of meaning when Christ dies on the cross?

Analyst

Yes. In the Book of Job. Job is a decent family man who lives a dutiful and honorable life, but things do not turn out well, he losses everything, his family, his house, his prosperity, and his health. "Job is visited by three friends, and each of them tries to justify his misfortunes. The greatness of job is that he does not except this deeper meaning. When, towards the end of the book God himself appears, God gives right to Job. He says, everything that your theological friends were telling you is false, and everything Job was saying is true. No meaning in catastrophes."[31]

Curator

The first step in delegitimizing suffering.[32] There is no reason for the holocaust, no divine message from world war, no meaning to the onset of plague. God sacrifices his own son on the cross.

Analyst

In fact not just the representative of God dies on the cross, but precisely the death of God as the absolute master, that controls everything, contributing to some higher harmony, dies on the cross.[33] "Our suffering is the real, it cannot be redeemed."[34] In Christianity God trusts in us, he dies and gives 'it' to us.

Curator

Entrusting the fate of creation into us. 'It' is freedom.

Analyst

The gift of freedom, this relates to what you were saying, not only in the decentralization of meaning in creation, but also connects to the idea of encounter.

Curator

The Holy Ghost?

Analyst
Mhhmm.

Curator
God becomes the encounter; he is engaged with what happens here on earth

Analyst
"Whenever the two of you are there, I am there." The Holy Ghost.

Curator
The creator is no longer some substantial master up there, but is in the spirit of the encounter of community.[35]

So the creative force is on the level of the encounter. There is no higher, a priori meaning to appease and to respond to. Things are, and we encounter them.

Analyst
There is no Big Other.

The Curator looks shocked. A few beats pass as she goes through numerous facial expressions of thought and emotion. Finally.

Curator

Knowledge is constructed. It's precarious. There is no Big Other?

(*silence*)

Analyst

I think we should stop here. When would you like to come back?

...

CUT TO:

Darkness. We are in a dark interior. The only thing that appears—drawn curtains that emit a faint glow of light from the exterior. A distant monotonous sound of traffic, the constant hum of cars driving through wet streets and thin puddles, an irregular and sparse patter of rain dropping in the wind. A cigarette is lit with the crack of a match, leaving a singular glowing ember that trails around a small area of the darkness with varying intensities as it is sucked upon breathlessly.

Alien

Mary.
Everyone seems to call you a curator, but yourself? You seem to resist defining your practice. Do you see this gap between 'this' and 'that' as a space to straddle and navigate?[36]

Curator

I am an artist.

Alien

Do you think exhibitions should make sense? Traditional conceptions of curating involve the illumination and explanation of information, particularly putting works of art into context so that something makes more sense than it had before. What about obfuscation and complication?

Curator

The difference between reality and fiction is that fiction has to make sense. Reality has no obligation.

I am an artist.

Alien

Do artists have investments in that divide?

Curator

Yes, artists and art don't have to make sense either, and to force sense in them should be punished.[37]

zzzzz ……………………

Art as Revolution, Escaping the Jail of the White Cube and Stranglehold of Art History

II

"Art is dead, long live art"[38]
—Mikhail Lifshitz'
Slogan of Marx' Aesthetics

Interior Analyst's office, New York City.

Curator

"I guess I believe that the way we live, as artists, has a revolutionary potential. Would you agree with me? In other words, I believe if everybody would be an artist, we would be all free."[39]

The Analyst perks up in his chair, and leans in slightly.

Curator

I guess this is what Beuys is talking about, when he says everyman is an artist.

SCENE 6

Analyst

The German sculptor?

Curator

Yes, well, yes. I don't think I've talked about Beuys in years, I mean this is really stuff from back in my undergrad days, but Beuys radically opened up the idea of sculpture, taking what at its core is fundamentally and simply an overall shaping and forming task. Here it becomes true that sculpting of course can transcend materiality into the social, the environmental, the personal, etc. Writing can become sculpture. Thinking, communicating are tasks that are overall shaping and forming, and actually Beuys makes a case that all these examples do have a pseudo materiality. Ummm. Like for example he talks about speech being plastic. "What the mouth does with speech, the blubber it releases, these are also real sculptures, although they can't physically be seen, the air is worked on, the larynx is worked on, the inside of the mouth articulates, the bite, the teeth, etc. On the receiver's end, the sculpture drills itself into the ear. We must see the ear as a plastic organ of reception."[40] The sculpture becomes a form that has affect, the idea catalyzes a change, the molding of some 'other' 'thing'.

Analyst

Hmmm, a seemingly radical statement that is in fact quite logical. What do you think Beuys would say about the work we are engaged in this analytic setting?

Curator

Yes, for sure this work is social sculpture. The sessions are sculptural as they are shaping and forming. They have a catalytic effect that enables me to form and have some added mastery of my life. It's a creative process where we give meaning to the symbolic elements that make up who I am, and who I can become, or want to become. I guess it's like a private artwork. Or in this opening up of sculpture, our life itself is sculptural, we ourselves, become works of art. Its kind of a nice image, the sculpture of the self, if as artists we would give as much careful consideration, intuition and labor on this work as we do to our other artworks there could be quite lovely results. It's nice. A nice thought.

Analyst

This is what Beuys means when he says everyman is an artist?

Curator

Well, yes, I mean he would be happy to hear this interpretation, but he comes to this statement in a different way. The affects for Beuys, of everyone believing in and conducting himself or herself as an artist has a kind of a macro effect, it becomes political and has a revolutionary potential. And not to be confused with the idea that a revolution can only come from artists but from the concept of art. Beuys discusses that we must break from a kind of radicalizing normalcy. We are numbed by our controlling system, capitalism, which supplies us terrible things, junk that we desire to furnish and equip our dwellings. Take for example "the kitchen: most stuff in the kitchen nowadays is toxic, we know that. And now one has to see that one absorbs as little poison as possible"[41] but that in itself illustrates that we are already in confrontation with the times we live in.

"Everyday can become significant", "there's no area that is not shaped and formed, and that doesn't have artistic value."[42] If we turn and tune our conscious attention to this process all around us, we can ask ourselves what is the point of all this stupid stuff, and the nonsensical process

that forms it and brings it to us. "Then you come to the question of 'direction', of impetus, the motivation. Here you see that there's a particular juncture, at the root, where things go wrong. And this juncture is our concept of work. This is connected with the concept of art, but it's no longer imbued with the concept of art, no longer imbued with concepts of creativity, no longer imbued with self-responsibility—this is impossible in the kind of system we live in."[43]

The Curator falls silent. But then it becomes obvious to the Analyst that she is continuing the dialogue in her head. The silence ensnares her thoughts and propagates more silence.

Some time passes.

Analyst

It seems really that "the current system is not about growth—they just call it growth. It is in fact a process of shrinkage and contraction." "It is actually a death process."[44] The external growth develops like a cancer, which simultaneously flourishes while consuming itself and everything that is not yet itself.

The Curator acknowledges an agreement. While the Analyst carefully formulates a tension to reengage the gap and pull of the real.

Analyst

You're presenting a position of impossibility in the face of this, suggesting "even if someone wishes to, he can't take real responsibility for his actions since everything is, as it were, done from above downwards."[45]

Curator

Well no. I'm suggesting that its impossible under this system, but one can break through. It can all be changed but you must work to achieve this, by developing a real interest in putting things right. Work. Our concept of work is the fatal genome. The revolution hinges on work, our idea of work must breach and become sculptural, we will shape and form effectively and productively not foolishly, automatically and greedily. "The concept of economic growth and the concept of capital and all that goes with it, does not really make the world productive. No, the concept of art must replace the degenerate concept of capital. Art is really tangible capital, and people need to be aware of this. Money and capital cannot be an economic value, capital is human dignity and creativity", "Art is capital. This is not some pipe dream; it is a reality. In other words, capital is what art is. Capital is human capacity

and what flows from it. So there are only two organs involved here, or two polar relationships: creativity and human intention, from which a product arises. These are real economic values, nothing else. Money is not."[46]

"We have a concept of capital where an economic value intervenes and wrecks everything, which therefore make the economy revolve around profit, exploitation etc. There is only human capacity and what flows from it."[47]

Whoa. But yes.
Wow. I'm kind of surprised that I ...

Quiet. The Analyst again presents a careful interpretation to break the silence.

Analyst
For you, or you through Beuys, when we work and nothing meaningful happens we are slaves in a matrix and implicate ourselves as errant cogs in the death drive machine. When we work and our work has an overall molding and shaping, when our work embodies a meaning that gives rise and form to something important we are making art, no matter what the form, form of the making or the resulting form, may be. It seems to be about process.

The movement in-between. The gap between the product and the activity, seems to become the moment of art, in this definition.

Curator
Hmmm—yes. I feel that way. Well, except its not a definition, I'm not looking to define, it's an interpretation. Or I guess an opening up, I mean, I think art is also about freedom. It must be free. I mean I guess that's what draws me to it, it's the one field of work where you can really do anything, really. It can really be free from the frames of discipline and can also work to push those disciplines to new discoveries or methods within their framed contexts. I mean one good work of art could be anthropological, scientific, mathematical, psychoanalytic, archival, poetic, theatrical, visual, architectural...

But I guess people really do want and need things to be framed; everyone wants to know what little box to put things into.

Analyst
framed art in a box.

Curator

Hah.

Shit! Yeah, or framed art in a white cube.

CUT TO:

Interior. The Curator's New York City apartment. The bedroom with onsuite bathroom. A Miles Davis soundtrack mixed with white daylight filling the rooms. Mary is dressed very, very casually, and props herself up with one arm, hovering over the New York Times and sipping black coffee with her other. Things seem nice. The sound of typical cosmetic noises come from the adjacent bathroom, the voice of the Alien, speaking quite loudly, over the running water can be heard from the bed.

Alien

You know, in the mornings, when I'm barely awake, I always see myself brushing my teeth in the mirror. Barely awake. Watching in the mirror, the rhythm of my elbow moving up and down. Up and down. Again up, then again down.[48]

Mary listens casually enjoying her morning daze.

Alien(continues)

Sometimes it seems to me that this, is an art, I feel like I could be making art. Even though this activity and this context, doesn't suggest art in any way.

Curator

Ha yeah. I know what you mean. The practice of such an art, which isn't perceived as art, is not so much a contradiction as a paradox.

The Alien sticks out through the doorway as the sound of water continues to run in the sink, still tethering him inside.

SCENE 7

Alien

You know what I mean, I'm not suggesting that an event like brushing my teeth each morning is chosen and then set into a conventional art context...

Curator

Bringing non-art into art, as Duchamp and many others since him have done. Using the strategy of the art-identifying frame, the gallery or the theatre, to assign "art value" or "art discourse" on some nonart object, idea, or event.

Alien

Yes, exactly. I mean, Duchamp's initial move, was sharp and ironic. But then...

Curator

It became trivialized, as more and more nonart was put on exhibit by others.

Alien

I guess in many cases there was still merit in these instances.

Curator

Regardless of merit, the same truism are headlined

every time we see a stack of industrial products in a gallery, every time daily life is enacted on a stage: that anything can be aestheticized, given the right art packages to put it into. All the irony is lost in these presentations, the provocative questions forgotten.

Alien

Yes, precisely not what I'm suggesting, to go on making this kind of move in art seems unproductive. I've been working very differently.

Myzeritteus moves the morning ritual into the bedroom and slowly but regimentally continues to dress the Earth body with the Earth clothes. The toothbrush is still gripped in hand, and is gazed upon every once in a while speaking.

Alien(continues)

Instead, I've been paying careful attention to brushing my teeth, to watch my elbow moving, and moving. I'm alone in the bathroom, without art spectators. There is obviously no gallery, no critics, no one to judge, no publicity.

This is the crucial shift that removes my performance of everyday life from all but the memory of art. I could have of course said to myself, any morning, "Now I'm making art!"

But actually, in this practice, I haven't been thinking much about that in particular. My thoughts and awareness are of another kind. I started to pay attention to how much this act of brushing my teeth had become routinized and unnoticed; that my mind was always somewhere else; and that ever since I got used to it, the thousand signals this body sends me each minute were ignored. I guessed also that most Earth people are like me in this respect.

Curator
Yep.

Alien
Brushing my teeth attentively for weeks, I gradually became aware of the tension in my elbow and fingers. Was it there before? The pressure of this brush on my gums, their slight bleeding, is something wrong, blood? I looked up once and saw, really saw, my face in the mirror. This was an eye-opener for me, to my privacy and to my 'humanity'? An unremarkable picture of myself began to surface, an image I'd created, but never really examined, closely, really examined. The way this image of myself, colors the images I make of the world, and influences how I deal with my images of others.

Curator

Little by little.

Alien

Am I resonating to far from where I started?

Curator

No, I'm following you. And your process of brushing your teeth.

Alien

I should point out immediately that this is the first time I've talked about this, and that it has never left the bathroom. The physicality of brushing, the aromatic taste of the toothpaste, rinsing my mouth and the brush, the many small nuances such as right-handedness causing me to enter my mouth with the loaded brush from that side and then move to the left side—these particulars always stayed in the present. The larger implications popped up from time to time as the work progressed. All this from tooth brushing.

How is this 'art', relevant to art?

Curator

Well, because developments within modernism itself led to art's dissolution into life sources. Art in the West has a long history of secularizing tendencies, working against arts propensity for the spiritual, religious and magical, going back at least as far as the Greeks in the Hellenistic period. By the late 1950s and 1960s this lifelike impulse dominated the vanguard.

Art shifted away from the specialized object in the gallery to the real urban environment; to the real body and real mind; to communications technology; and remote natural regions of the world, the ocean, sky and desert. Thus the relationship of the act of tooth brushing to the artworld as it's constructed itself, cannot be simply bypassed. This is where the paradox lies; an artist concerned with lifelike art is an artist who does and does not make art.

Alien

An artist but also a not-artist. Anything less than paradox is simplistic. Unless the identity, and thus the meaning? Of what the artist does, oscillates between ordinary, recognizable activity and the 'resonance' of that activity in the larger

human context, the activity itself reduces to conventional behavior. Life? Or if it is framed by a gallery or a stage or a screen, it reduces to conventional art. Art?

Curator
So, tooth brushing, as we normally do it, offers no road back to the real world either. But ordinary life performed as art/not art can charge the everyday with metaphoric power.

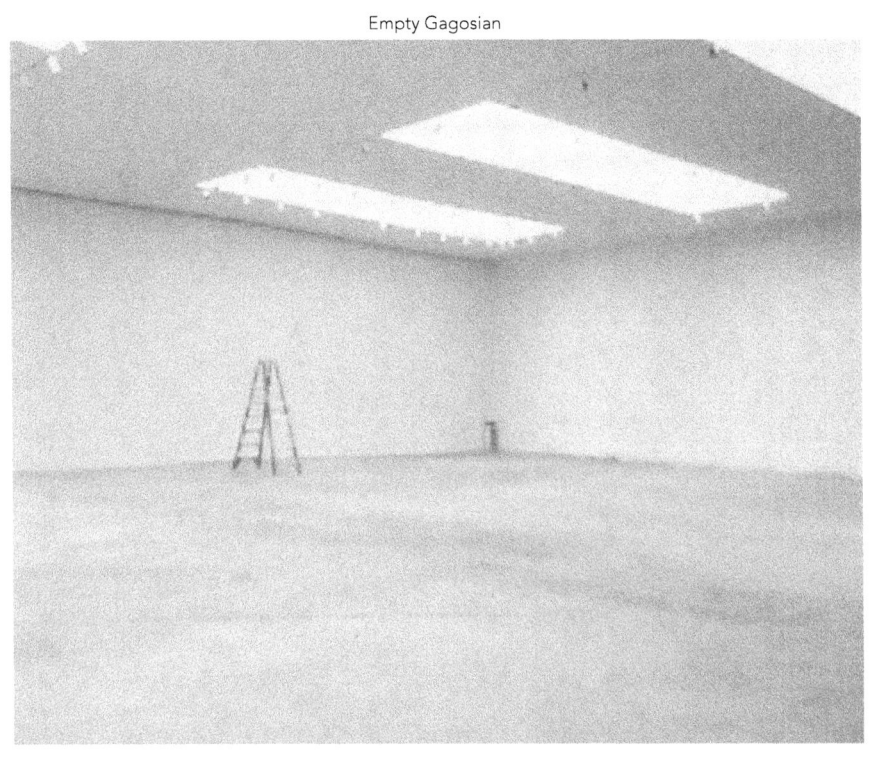
Empty Gagosian

The Curator and the Alien walk the Chelsea district of commercial galleries. They are en route to a meeting with Larry Gagosian, the juggernaut of commercial galleries, representing an extensive list of the most successful artists of all time, alive and dead. Gagosian knows goldmines, and it didn't take much convincing from Mary to secure the opportunity for Myzeritteus to show concurrently in his two Chelsea district spaces. Gagosian will feed the frenzy of collectors who will devour a chance to collect the first non-Earth artist. However, the Alien is completely freed from the abstract concept of money like no other artist or non-artist before him, or at least for the last few thousand years, in fact Myzeritteus Mêtis is also free from the abstract concept of linear time.

Alien

These spaces are unsuitable, in fact unusable; they only propose a closed system and a strict rule of 'form before content'. No way, not doing it.

Curator

Come on.

Alien

Radical white jail cubes, "a ghetto space, a survival compound", "a place deprived of location", "a magic chamber"?[49]

Curator

I get it. I know I know. But seriously I thought that it was clear. This space is the best gallery to exhibit in America outside of the museums.

Alien
What about everything we've been talking about.

Curator
You can't be serious.

Alien
And the ideas we've been working around?

Curator
People would kill for this opportunity with their first show. It's beautiful. There's always the possibility of reacting to the problems you have with showing in this context by subverting the space. There are so many great exhibition moments of artists who have worked within the gallery to show the failures of the gallery. Again starting with Duchamp, Coal Bags and Mile of String, Michael Asher's show at Galleria Toselli in '73, Robert Barry's Closed, Mike Nelson with To the Memory of H.P. Lovecraft, and...

Alien
I don't care; I will not let the gallery space dictate my work. Some creative reaction to it still operates in this closed system; it really doesn't interest me, at all, to work within these extreme limitations.

It "gives off negative vibrations when we wander
in. Esthetics are turned into a kind of social
elitism—the gallery space is 'exclusive'. Isolated
in plots of space, what is on display looks a bit
like valuable scarce goods, jewelry, or silver:
esthetics are turned into commerce—the gallery
space is 'expensive'. What it contains is without
initiation, well-nigh incomprehensible—art is
'difficult'. Exclusive audience, rare objects
difficult to comprehend—here we have a social,
financial, and intellectual snobbery which models
(and at its worst parodies) (your) system of
limited production, (your) modes of assigning
value, (your) social habits at large. Never was
a space, designed to accommodate the prejudices
and enhance the self-image of (your) upper middle
class, so efficiently codified."[50]

A gallery is a place to sell things. "A business
of assigning material value to that which has
none."[51] How does this become a real concern for
art and the artist?

Curator
Shit. Fuck. I'm screwed. What the hell am I going
to say to FUCKING GAGOSIAN!

Alien

Art is of great social use. The people of Earth "tend to avoid specifying this use, because one of art's outstanding attributes is supposed to be a certain uselessness; or then again people say that its usefulness consists in the fact that there is something in it which evades common usage and is loved selflessly. To be able to love selflessly is the flower of the human spirit."[52]

Curator

Yeah, why don't I just tell him that! Why don't we just say, we don't want to work with capitalist pigs like him because we are the flowers of human spirit!?

Alien

Art that is made for sale on or taken by the market radically alters its determinant characteristic, transforming its use, or uselessness.

The Curator fumbles for and lights a cigarette, the pace of her gate increases putting a slight distance between the two, changing her reception to the conversation. She no longer listens but gazes towards the ground looking for solutions and compromise as the Alien continues.

Alien

It is such a fundamental change that it cannot logically maintain the same term. "If the concept of art is no longer tenable for the thing that emerges when a work of art transforms into a commodity,[53]" "we must carefully and discretely yet without trepidation drop this term"[54], "if we don't wish to liquidate the function of the thing itself; because it must pass through this stage, without looking back. This is not an optional digression from its true path."[55] "What happens to it here, is going to change it profoundly, eradicating its past to an extent that, were the old term to be resumed, and it will be, why not?— it will have ceased to evoke any remainder of what it once described."[56] "The stage of the commodity will give up its present specificity, but it will have invested the work of art with quite a different specificity."[57]

Curator

I'm a piece of shit.

Alien

I find it interesting that in your culture, this white cube gallery space simultaneously preserves the possibility of art but makes it difficult.[58]

SCENE 8

"Is its obsession with enclosure an organic response, encysting art that would not otherwise survive?" " An economic construct formed by capitalist models of scarcity and demand?"[59]

The Curator stops in front of Gagosion's Madison Avenue office and gallery, takes a hard final puff on her cigarette before flicking it to the gutter.

Curator
"For better or worse it is the single major convention through which art is passed."[60]

Alien
"What keeps it stable is the lack of alternatives." "Genuine alternatives cannot come from within this space."[61]

Curator
Ok so now what?

Alien
Its ok, we simply and politely tell him we will make works outside of the commercial gallery. He's a smart man, he'll understand.

Myzeritteus embraces Mary and speaks in a sympathetic reassuring tone.

Alien

"Sometimes it's safer to sound off about large political matters then to clean up your own kitchen. Political courage is measured by the degree to which your position can, if prudently pursued, hurt you. It's less comfortable to begin the political process at home."[62]

A Ghostbusters Art History of the Met (http://ghostbusters.wikia.com/wiki/Metropolitan_Museum_of_Art)

Exterior. 5th Avenue, New York City. The Metropolitan Museum of Art.

The Alien stands at the threshold and questions the Museum. Myzeritteus has to say something to Art History, to Kant, Gombrich, and Greenberg. But doesn't know what to say.

Alien

Do you have a message for me?

```
                        Museum
                      Naturalism
                  vanitas  photography
         neo-conceptual  appropriation
                   outsider    installation
          catalogue        triptych
                    Bauhaus       retrospective
              collection       ism
                     pop              Russian
                criticality    relief
                     Rembrandt         semiotics
                scale        mannerism
                     beauty              western
                  wall        expressionism
                   sculptural            avant-garde
                   reading     fresco
                     participation         millions
                      romantic    neo-classist
                   aesthetic                  intellectual
                      white        ism
                    Egyptian                    genre
                       view         Paris
                    painting                      feminis
                       fake         Picasso
                   modern                              post
                          form       landscape
                ism
                           perspectiveKandinsky
                  London
                            medium     trompe l'oeil
                     relational
                              frame      New York
                     spectator
                               Italian    isms
                    contemporary
                                  Minimal   abstraction
                        sublime
                                    collage  vanishing po
                        action
                                    ism       legacy
                                            style
```

Hundreds of voices sound off layering one over the other in a deafening cacophony of meaninglessness. Myzeritteus leaves and gets back to work.

Nothing is Better Than Nothing; Enjoying the Vacuum

III

> "'Good Work,' he said and went out the door. What work? We never saw him before. There was no door."
> —Richard Braugitan

rt and particle physics? Work?

Chalk on Slate to Remember the Future

SCENE 10

Alien

Time is not linear, however it is experienced as so.

Exterior. High, high above Geneva. The tongue of a bluegrey lake peninsulas down and between two mighty mountain rages, to a city. Lower and lower. And still lower and lower, the terrain cuts into grids of farmland, countryside and industry. Lower and closer, still closer and lower, circular motifs are cut into the landscape and architecture. And then the above ground campus of buildings that situate CERN.

The Large Hadron Collider. A hypnotic mass of perfectly symmetrical tubes, tunnels, steel, grid and structure with the scale of a spaceship. Built to withstand temperatures colder than space and hotter than the sun. The Alien is before and communicates with, 'It', 'the LHC', 'CERN', 'the Symbol'.

Alien

I am finally beginning to understand how earthmen see time. This was most difficult for me to unravel, I had to observe and analyze very closely before I could even come to understand the possibility of this linear projection. I am bearing witness to the 'Arrow of Time'.

CERN

Ahhhh, meditations on time. Of course. And analytic discoveries.

Alien

In almost all equations, spatial equations, temporary equations. There is a deep symmetry in physics, that doesn't really distinguish

between the past and the future. There is a weird discrepancy between what the equations say is happening, that time is symmetric, and our experience of time, that time is flowing in one direction only.[63]

A cold, hummmm.

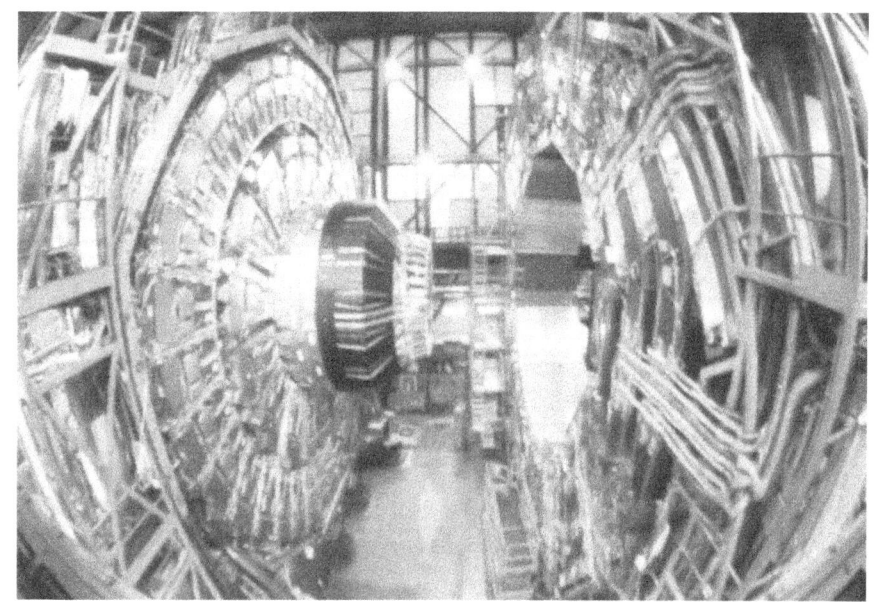
After Before the Collider

CERN

Quantum mechanics (but also in other fields) works to explain this arrow of time. One possible explanation is, we only experience time as flowing forward because the current state the universe is in. Because it is in an expansionary faze, but at the moment when the universe stops expanding, there seems to be a possibility that there is enough mass in the universe to stop the expansion and start a contraction again. Then at that moment, time will actually flow the other way around. So what we see as memory now will be anti-memory in a way because you will remember the future and not the past.[64]

Alien

With movements of a visionary.

Time-based art is, in fact, art based time.[65]

Interior. Bedroom. Curator's apartment and then maybe somewhere more grand and romantic. Like a Casper David Friedrich landscape. The two meander, and to both of them it feels as though something is at work. Both are unable to figure out what it is, and think about raising the question to each other. As usual the Alien carries on in his ongoing dialogue with the world through the Curator.

ler ~~~ jena jena. Bitte? Wieder rückwärts.

Alien
Meaningless work is obviously the most important and significant art form today.⁶⁶

The aesthetic of meaningless work cannot be identified exactly. Meaningless work is honest.

Meaningless work will be enjoyed and hated by intellectuals, though they should understand it.

Curator
Meaningless work cannot be sold in galleries or win prizes in museums.

Alien
Though old fashion records of meaningless work (most of all paintings) do partake in these indignities.

Curator
Meaningless work can make you sweat if you do it long enough.

Alien
Meaningless work is potentially the most abstract, concrete, individual, foolish, indetermined, varied, important art-action-experience one can undertake.⁶⁷

The two keep the conversation busy, talking about almost everything, except addressing the unusual 'thing' that somehow seems to be at work between them. Its quiet, a lull grows from the magic-hour light as the sun prepares the day to set. The air is pleasant and crisp; the forest grows still and slightly stiller.

Curator

Its nice here with you. I'm glad you came.

Alien

I think the same.

The light drains out of the forest. As the darkness takes over so does the unspoken, into a comfortable shared silence. And night.

Exterior. Busy New York street scene. Late, Mary fumbles out of a cab paying the driver of the car that is stuck in a jam of traffic. She rushes to join the pedestrian wave along the sidewalks, blending in and following, tunneling into the underground concourse for the subway. Packed train.

CUT TO:

Interior. The Psychoanalyst's New York City office. Mid session.

Curator

—Everyone accepts Peter Higgs work as significant, we've constructed CERN and the large hadron collider for over a billion dollars with operating costs over a hundred million each year, the theoretical physicist has been awarded the Nobel prize and the discovery of the Higgs-Boson particle is declared as one of the most important discoveries in scientific history.

But what about when he started? Before the accolades? What about the forty years of work leading up to this moment? What was this work, what does it look like? Thinking? In a quiet closed off room, sitting in his thinking chair, standing up every once in a while, pacing back and forth, more thinking, maybe a walk in the park, some diagrams, drawings, reading, calculations, building an idea, failing, some more thinking. This is work.

But this work, in the context of our 'normal society' cannot be considered real work. The average person is perplexed at how this is work.

So dominated by the ruling capitalist system. The young theoretical scientist is considered an outsider, a weirdo, a bum, or a loafer. His work doesn't fit into the model of production and consumption and is therefore not considered as real work. Until of course, he is championed by the capitalist system as a genius. What about if the work he does, isn't proven correct or significant? Is the work of the theorist then not worthwhile?

I think this force is only gaining strength. Higgs himself stated that he probably would never have been able to lay the theoretical groundwork to make this discovery today. There is no funding anymore for conceptual work in the sciences. When he began, there was no proposal of what he might find, or even what he was looking for.[68] How could there be? How can you know what you're looking for, if you're looking for something that has never before been conceived? Higgs was simply searching. He was willing to dedicate his time and work on the unknown, to nothing. But today there is no justification for this kind of work, no more funding or true respect for theoretical science.

Analyst

Hmmm.

Analogous to the situation in the liberal and fine arts.

Curator

Yep, goodbye culture. I think its quite noble to pursue this nothing. Or what looks and seems like nothing in this system.

I think it also applies to this work. The work we do here. Psychoanalysis.

Analyst

Mmm, Perhaps. What were you thinking?

Curator

Well, it sure seems like your doing nothing. I remember during the first year when I was coming here, it felt really therapeutic and a bit indulgent to just spout off and kind of use you as sounding board. You know, get things off my chest and complain, and also I think I kind of positioned you as a second, kind of, conscience, like a bit of a pseudo parent that I had to report to. I didn't really even care what you were doing or if you were really adding anything. And then things started to change. It got really difficult; I got sick of hearing all my own

bullshit, I started noticing all my justifications and fantasies and projections, and wondered why you weren't saying anything. I remember getting a bit angry with you; I wanted answers, what was your analysis? What were my problems? Did I have anxiety disorder, was I bi polar? What was I paying you for? I wanted some results. What the hell were we doing here?

Analyst
Yes I recall. I believe I responded that we were practicing psychoanalysis, this was talk therapy.

Curator
Yeah, I remember feeling like I was on the precipice of quitting, firing you. This answer wasn't good enough for me, what the hell is talk therapy? What you said continues to resonate. You stated quite confidently in the face of my hysterics, that, this is simply a forum for questioning, for questioning ones life, ones decisions, our worldviews, work, everything and anything.

Analyst
Mmhmm.

Curator

This simple statement calmed me, as I pondered it.

I was so conditioned by the other 'normal' dominant forces at work. Governing every aspect of my daily life that I failed to give a value to this type of 'unproductive' work. In my eyes, trained in our capitalist system of production and work, it really really looked like you were doing nothing. But from this point on I slowly began to see, understand and enact positive changes on my life. And then even later, with a bit of research I began to understand and observe the subtle techniques employed here. Techniques that look for what is not here, what is not said, what is not known, in order to stimulate discovery. How can one truly make a discovery by looking at what is already known. I really now see the value in this perceived nothingness, I'm enjoying the void that you present here.

But it must be difficult to justify the practice of this kind of work in the face this system we find ourselves in.

Analyst

We are fortunate to be able to continue this work.

It may not always be this way.

Curator

What do you mean? Oh, to be recognized by the insurance companies and governing heath care systems and such.

Analyst

Yes. Mmhmm.
We are united to maintain our recognition. But it may not always be this way. We are fortunate to be able to practice this work.

Curator

Hmph. To practice this important nothing. Creating this void space that is filled up with potentials... A nothing, which produces.

Analyst

Lacan continues in the same ironic vein, stating for instance that "psychoanalysis is nothing other than what is expected of a psychoanalyst."[69]

CUT TO:

Interior. The room is dark; it is the dead of night. The Alien sits hunched over at the foot of the bed, earth body uncovered, disheveled, from the point of view of the Curator who reaches over to flip on the dim lamp beside the bed, Mary is still at least half asleep as she speaks.

Curator

Are you all right?

Alien

I don't know.

Curator

Were you dreaming? Did you have a dream?

Alien

I don't know.

I don't know what a dream is. I was lying right here in the bed. And someone was knocking at the door. The knocking persisted and I got up and headed towards the sound. I noticed I was fully dressed and recalled finding that slightly unusual. The pounding at the door seemed to intensify as though who ever were on the other side was growing more desperate to enter. As I approached I realized that the door was quite different, it seemed to be from another time and

place all together. Confused, I turned back to re orientate myself in the room, but you were gone, everything had changed. I found myself in what seemed like more of a theatre than a domestic space; everything was black except for a small dramatically lit scene that had gathered around. They were all dressed as though from a 17th century painting. One man, who was either wise or mad or both seemed to be at the center, making a demonstration or lecture for the others that surrounded, young boys and girls, perhaps their father, a few serious contemplative men, and an infatuated couple. I began towards them so I could also observe. I was able to approach unnoticed, as if I was a ghost. There were a number of curious magical scientific objects that reflected off a perfectly varnished table that hosted the gathering. A long elegant pedestal was the centerpiece; atop the pedestal was a large glass bell jar that sealed in a small white bird. The grey haired lecturer manipulated a pump that was attached to a tube that came out of the base of the stand, slowly removing the air from the bell jar that enclosed the white lark. The demonstration of this drew varying responses from the onlookers, children hiding their eyes, turning away, men calculated and observing, I moved in

closer. "—the bird for a while appeared lively enough; but upon a greater exsuction of the air, she began manifestly to droop and appear sick, and very soon after was taken with as violent and irregular convulsions as observed in poultry when their heads are wrung off: For the Bird threw her self over and over two or three times, and dyed with her breast upward, her head downwards, and her neck awry."[70]

Curator
Intense.

Alien
I was quite enthralled and had entered the picture I was observing. I suddenly felt eyes on me for the first time, implicated, altering my previous statues of ghostly onlooker. The grey haired pedagogue looked directly into my eyes, his expression blank and his gaze demanding, as if somehow asking me to interpret or judge what I had just witnessed. But I was just somehow trapped, paralyzed by his gaze unable to respond.

Curator
Strange. And then you woke up? Back here where you're supposed to be.

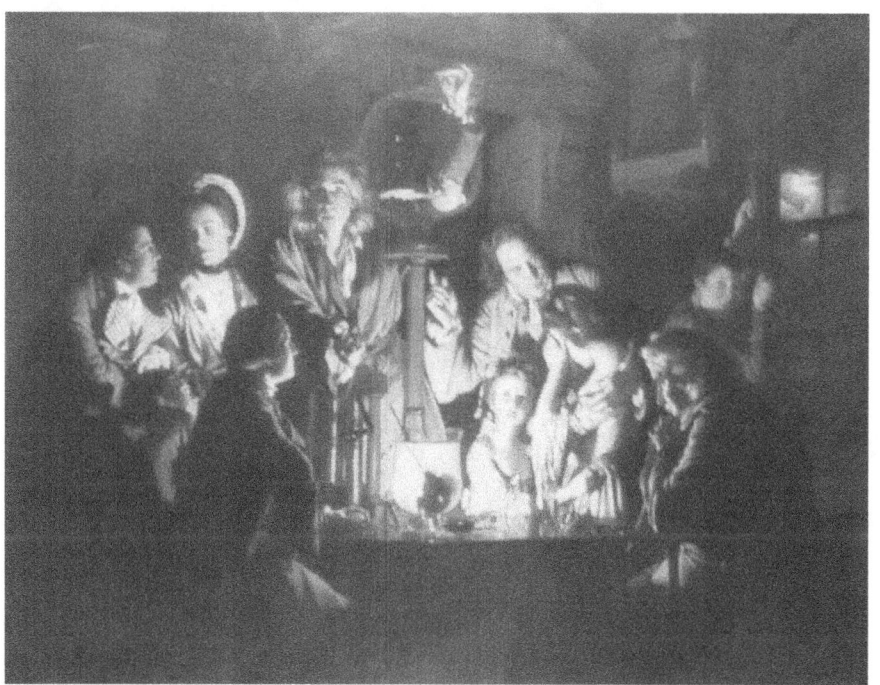

Suffocating Discovery of Dreams

SCENE 13

Alien

No. There was one more thing that I remember. But it also doesn't really make sense. I was back in bed, still in my clothes, confused, I thought this strange memory or event was over. But then there was a man sitting beside the bed, upright with legs crossed in a chair slightly behind me. First I just heard his voice and it startled me, I had to strain looking over my shoulder to see where his voice was coming from. He was asking what I thought it all meant. Asking me about the bird, and the children, and the moon, and the lovers and what I thought they all symbolized. I don't think I was able to answer him, but I don't really remember.

Curator

Do you remember the man, what he looked like? His voice?

Alien

Yes. He was dressed very smartly in three piece tailored tweeds, quite bald, with a grey beard and round spectacles. He was puffing on a large fat cigar. He was for sure of German decent, or perhaps Austrian.

Curator

Sounds like Freud, Freud himself was in your dreams, amazing.

Alien

I definitely felt as though I recognized him or had seen his image before. So this surreal event that I experienced is a dream?

Curator

Yes. It's a pretty strange phenomenon, that somehow we grow quite accustomed to I guess, this twisting of reality and sensory experience, somehow becomes normal and we discount its significance for the most part. It is definitely very human to dream.

Alien

This body is affecting me quite dramatically. I'm not sure. I'm not sure what is real? I'm... I... I don't know. This... this seems to open up so many questions and possibilities and ... things are becoming...

So abstracted... Reality?

Time? Space?

The curator has fetched a glass of water, the Alien drinks still disheveled and suspicious of everything. She fixes the mess of hair and slips a cardigan sweater over the shoulders. She delicately slaps at the face and attempts to draw the Alien out of the contemplative disorientation with her gentle gaze.

Curator

Well, I'm not sure about all the vivid stuff you witnessed in the dream but the man you saw, who spoke to you before you woke up, was definitely a representation of Sigmund Freud, which is quite cool actually.

Alien

Yes, I am aware of the significance of this man for you, you people.

Curator

I suggest you let him come to you again. You should speak with him. He can probably answer many of your new questions. It becomes quite complex but dreams and reality can be explained or understood and restore your faith in the state of things as they exist. And maybe it is worth exploring, analyzing and interpreting this dream of the 'experiment on the bird in the vacuum' further. It in itself may provide some answers.

Alien

This dream work ... So when I'm asleep, I'm still at work on important discoveries. Able to work in ways that ... if only ... how can I truly access the 'Real' ?

Curator

Come back to bed. Sleep on it, and we can get started again in the morning.

The Alien fumbles to get dressed by the moonlight. He will not be returning to sleep until he is equipped with a plan.

It seems like serious work is getting done.

Interior. A grand private library. The Curator sits. Nothing more. The still life that she occupies implies past and future activity. A packet of future cigarettes, an ashtray of past. Flowers harvested dead days ago but kept fresh on support by the still water at the bottom of the Victorian vase crafted a hundred years earlier by the ghost at the window of the long dead artisan. The coffee cup is as empty as the closed books strewn about the wooden desk. The pen is prone and capped and useless. The papers are blank and white and could start a fire if given to match. There is no tick from no clock. No tick and no tock.

Curator
"How can anything be said about nothing without violating its very nature?" "Perhaps we should let the emptiness speak for itself."[71]

CUT TO:

Exterior. An isolated dreamlike scene. The Alien is before the sea. (Casper David Friedrich again) The beach is massive in its length, clinging along the coastline with great width, threatening to be ripped away by the rhythmic crashing of the breaking waters against its shore. The wind is strong and cold and whips swirling as mist. The waters almost black and froth and spit into the Alien's face as he gazes into its void. A constant, white, hum and howl and smash and cry and batter and clap ringing through the ear and air. Occupying the 3+1 dimensional stratum but possessed by its absence. As if succeeding in disappearing, without losing sight.

Alien
"Nothingness is not absence, but the infinite plentitude of openness."[72]

CUT TO:

Interior. Blinding white daylight pours in through windows and bathes the modern white desk in more white. The Psychoanalyst writes in his notes and reads the dictation aloud.

Analyst

They had trouble separating themselves from the void, mythology had no charm for them a hollow thing on the plateau with their parabolic reflecting bodies, with space, the lawn for the lunatics in the asylum, the pine tree of irreproachable dynasties —Augurs of themselves. They delighted in symmetrical and terrible mediations such as the game of dice (their faces diversely punctured, space upon space.)[73]

Cut back to the Curator in the library: speaking slowly in trance.

Curator

"An empty page signifies more than a written page."[74]

Cut back to the Alien at the sea: gesticulating and speaking wildly into the face of the ocean.

Alien

"The void is a lively tension, a desiring orientation toward being/becoming. The vacuum is flush with yearning, bursting with innumerable

imaginings of what could be. The quiet cacophony of different frequencies, pitches, tempos, melodies, noises, pentatonic scales, cries, blasts, sirens, sighs, syncopations, quarter tones, allegros, ragas, bi-bops, hip-hops, whimpers, whines, screams, are threaded through the silence, ready to erupt, but simultaneously crosscut by a disruption, dissipating, dispersing, the would-be sound into non/being, an indeterminate symphony of voices. The blank page teeming with the desires of would-be traces of every symbol, equation, word, book, library, punctuation mark, vowel, diagram, scribble, inscription, graphic, letter, inkblot, as they yearn toward expression. A jubilation of emptiness."[75]

SCENE 14

Nothing is Better Than Nothing

SCENE 14

Techniques to Finding Mass in the Void;
Dreams, Boredom, Violence, Interacting Forms, Symbols &
Signs, Death

IV

> "It is dreams that constantly remind us of freedom—there is no other source. Dreams give us impulse to distrust all necessity, to despise the iron rule of the status quo. In dreams I have tasted blood. Dreaming, I become aware of possibilities that reality denies me over and over again."[76]
> —Durs Grünbein

The Alien searches for the 'Real'. Collège de France, Sorbonne, Paris. It might be 1975 or 76. A loud flow of people, students and intellectuals course out of a lecture hall and into the pre-Beaubourg echo-infested hallway. Myzeritteus begins to slide and push up-stream, slipping into the seminar room. Erasing erratically at the lesson's notes from the large blackboard, is the Professor, a bit aged with grey puffy hair pulled up and back, and dressed a bit on the flamboyant side of professionally, or perhaps just in accordance with the style of the era. Myzeritteus introduces himself as the final scholars trickle along the hard vociferous tiles and out the large wooden doors.

Alien

Greetings sir, I am Myzeritteus Métis, an artist from the future and alien to earth, I am in search of the real, and my research keeps leading me to your work.

The Professor slowly pulls an oversized handkerchief from his pocket and loudly, ostentatiously blows his nose.[77]

SCENE 15

Professor

All right then. Lets proceed to my office; I have some time before I begin my scheduled sessions.

Interior. Professor's office. Myzeritteus is lead past the expected collection of antique bric-a-brac in a lighted cabinet. The Professor promptly takes a comfortable seat behind a table covered with open books and the Alien is left to consider where he will sit. In the place of the usual divan is what looks to be a barber's chair in a semi-reclining position.[78] Objecting to the use of this unusual chair for the purposes of the discussion, Myzeritteus removes a stack of books from a standard wooden chair and begins to take a seat at the table.

Professor

Bon. Ok. You're interested in my work. Lets go. But before we can begin. "Wipe your glosses with what you know."[79] "Enjoy what you can follow, and if you do not understand it all, be comforted; for you are one at last with all scholars."[80]

The Alien settles onto the edge of his seat and looks on comfortably, ready. Their conversation follows with animation, but also allowing each other silences and gaps to find their rhythm.

Professor

There is no universe of discourse. Literally, universe, means turned into one. All knowledge is retroactively constructed or posited.[81]

Alien

Denotation and connotation come together. And come to mean something, meaning is produced? There is always more to know. And there are always other interpretations.

Professor

There are three points of convergence for any of what you've discovered to mean anything. One, The finitude of language.

Alien

The finitude of language. Its state of limits.

Professor

Two, the insistence of a beyond of discourse.

Alien

The beyond discourse. There is always more to know.

Professor

And three, the necessity of a subjective interstice.

Alien

The subjective interstice, our intervening space.

Professor

They make up three distinct but intertwined realms of experience. The imaginary, the symbolic and the real.

Alien

Ok

Professor

The symbolic refers to the function of structuration. Our experience is ordered through systems of equivalence and differentiation.

Alien

The stuff of language

Professor

Yes, what the symbolic does not include is meaning. Words are defined in terms of other words in what is, in this sense, a closed system.

Alien

Which always leads in a circular movement.

Professor

This closed system is symbolic. To discern or assume meaning in a word or collection of words

implies the convergence of the symbolic on another of the realms.

Alien
The imaginary. The realm of meaning.

Professor
We imagine that we understand what the other is trying to say. The realm of identification, when I assume to grasp a meaning, I necessarily come to place an idea of myself into the discourse in question. When I think that I have understood you, I assume a position between you in your position of speaker and me in my position of listener.

Alien
These points of imagining are always illusions.

Professor
Although as illusions they are necessary. We cannot not identify, but these moments of identification never touch grasp or present reality as such.

The Professor pours a small glass of water and sips before continuing.

Professor
Reality is always a combination of both the symbolic and the imaginary.

Alien
Even when we are not directly or overtly concerned with discourse, discourse is at work, framing and constructing.

Professor
There is no escaping the symbolic, nor is there escaping the imaginary realm, there is no experience of the world that is not affected by identification. The reality of experience is always an experience mediated and distorted through imaginary prisms and symbolic frames. The symbolic and imaginary are not, however, even in combination totalizing. There is always that which escapes their reach and insists from elsewhere. This elsewhere, this beyond symbolization and identification is the real.

Alien
That which cannot be grasped.

Professor
Yes, but which does not stop it from impressing.

Even this impressing will sooner or later transform through imaginary and symbolic processes.

It seems like the two are gathering steam. And may be setting the stage for several more hours of discussion. The professor takes a moment to light a big fat cigar and offers another to Myzeritteus.

Professor(continues)
Whenever we encounter a discourse, spoken or written—

Alien
Or art.

Professor
We encounter the materiality of the signifier.

Alien
The weave of grammar and materials, the conventions of syntax and forms, the possibility of what can and cannot be said in a particular language or medium.

Professor
But the encounter remains meaningless without the intrusion of imagination, which feeds on, and bounces off the language itself, conjuring

connections and identifications. Without a subject's engaging with a creating meaning with it, there can be no meaning...

There is no saying it all, and there is no getting it all and this not all is the impress of something beyond, the real that escapes discursive capture.

Alien
How can we talk of any 'thing'? A word is just a sound image. When we say the word which we mean to represent the thing that we imagine.

Professor
No amount of imagining touches on the particular material thing as remembered—

Alien(interrupting)
Which is also a form of imagining.

Professor(continues)
—by the person who tells of the particular thing in their story. At least two gaps are present here. No amount of imagining crosses the gap between imagined identification—I know the thing she is talking about—and the thing she is talking

about. No amount of imagining, her's or mine, closes the gap between imagining and the thing itself. Which will always remain beyond the picture, beyond—

Alien
In the real.

Professor
The process of identification or meaning creation is not an arbitrary one. The thing cannot simply be made to mean anything. But we cannot constrain the meaning either, the elasticity, the stretch of sense depends always on the receiver.

Alien
What precisely the thing signifies depends on the imagination of the receiver.

Professor
Depends on what the receiver imagines when confronted by the signifier. There is necessarily a tension here, then, between the fact that it could mean anything at all and that it doesn't mean simply anything.[82]

Alien

Hmmm, I imagine I understand.

Professor

Let's stop here; I have scheduled eight sessions for this afternoon, and only have three hours left. Good luck with your work and find me again. À la prochaine.

Evening. London interior. Dimly lit study. A well stocked and organized domestic library along one wall. A variety of pictures, drawings and paintings hung throughout salon style. Carpets and wood furnishings. The Alien is lying prone on the heavily covered and pillowed, classic, early 19th century, Biedermeier style couch, Freud's couch at the Freud Museum. The Alien doesn't sleep much anymore; he is busy working, at this moment on his first dream, communicating in session with Freud, the analyst through the object of his symbolic couch.

Freud

Ahh, Mmhmm. The event is well known. It's part of a series of experiments led by Robert Boyle during the year 1665 in his Oxford laboratory, which eventually led to the discovery or rather the invention of the void. These experiments were conducted with the newly invented "pneumatic engine" later to be known as the vacuum pump. The apparatus itself was quite simple. It was composed of one central element: a large blown glass sphere. The sphere was then rested on a tripod made of wood on which was fixed the actual pumping device underneath. The purpose of the apparatus was to test the effect of the rarefaction of air on various entities.[83] The way you described the dream was quite vivid and even cinematic. What do you think? Did your description recall a cinematic style or genre for you?

Alien

Yes, actually it did. I've recounted it now a few times. And this time listening, to myself, I visualized a science fiction style, kind of early 1980's Tarkovsky'esque. And in particular, the way I saw the final moments of the lark in the bell jar. The rest of the scene kind of disappeared as I fixated on the little world inside this pocket. "We could have very well been looking out the window of a space station—and as a bird is let out of the shuttle, we would see it go through the exact same process—suffocation and death—only to drift away slowly into the vacuum of space."[84]

Freud

"This scene would then be the reverted space of our initial situation where what was initially a pocket in our world became a world in which we are a pocket."[85]

Alien

Yes. A kind of paradoxical unfolding takes place ... where the interior properties are maintained on the exterior and vice versa ... What is at stake in the invention of the vacuum pump is much more than the observation of the properties of air or the effect of its absence on living organisms.

Nowhere better than here is played out the fundamental act of divide in history, the cut between 'woven significations' of the premodern and the basis for our modern constitution.[86]

Freud
The Enlightenment, emphasizing reason and individualism.

Analyst
Can the dead bird trapped in a vacuum serve as a sign pointing to nothing else than a newly formed hole in the world? I'm trying to understand how the death of a bird came to figure the void.[87]

(*silence*)

Freud
Hmmm, go on.

Alien
Must this event approach the real as a representation of the nature of being, can this violent separation not be mended with a morphological perspective, that of forms interacting within the structures of living.[88] In the biologically orientated sciences, the arrow of

time, the irreducible directionality of temporally irreversible phases, states and relations is only constitutive to an organism in its particularity.[89]

This scene is read in the same way as humans read the universe in the Pre-Copernican era, that everything rotates around the earth, that humans are at the center of the picture, a kind of total vanity. As if the universe rotates around man, as it's subject who gives it meaning. Humans are nothing, we know that now, man has accepted this.
Previous scientific models of nature have been ungrounded; mustn't these new theories in science also shake the ground of other fields, including art?

Man must reconsider his subjective positioning. And the subordinate relationship of the subject over the object.

The conventional implication of what the painting represents, posits a human domination over the world of nature. A picture of death for the subject. But the reality of this cut, this death, this violence for the subject, is in fact simply an ongoing living process. The world continues. There is no real mending required, things are proceeding as usual, with natural chaos and order.

Freud

What is this ongoing living process that you see in this picture that you have dreamt?

Alien

Well, the "problem when thinking about the 'living' is that there is obviously no possibility to overfly it as a subject as it is the very place from which we emit thought."[90] Human philosophy imposes a division between thinking and being that is, of course, nowhere given in nature. The universe is essentially inhospitable and meaningless. "Let's abandon the role of philosophy as a kind of feel-good supplement,"[91] and uncover man's indulgence in this "therapeutic role of philosophy."[92] Let's think like the most fundamental thing that 'is', that lives, but doesn't think, the cell. Consider the intrinsic geometries of a cell undergoing growth. The cell is constituted of three changing parts, "these three parts can be seen as three different states in a process: the interior of the cell being its past, the individualized constituted entity resulting of precedent processes. The exterior of the cell being its future, all that lies in front of it, all that will nurture or poison it. And the membrane of the cell being the present."[93]

Freud

"The junction of past processes and future becomings."[94]

Alien

In this reality, there is no separation between the humans observing this scene and the bird "but a series of degrees going from living to dead."[95]

In this relational space, "there would be no radical cut between myself and a stone but a full continuum oscillating between the inert and the living."[96]

Freud

"What does it mean to speak of a gradient from life to death?"[97]

Alien

Recent advances in the Earth science of biology "have come to revise entirely such positions and integrate death as a morphological process in its own right: a pure discontinuum shaping the continuity of processes."[98]

Freud

Death...

Alien

"At this cellular level, the process of death acts as a sculpting device."[99] "In a series of recurrent waves, cellular death sculpts our arms and legs from their rough initial shape. In the interior of our forearm it creates the space separating our bones—it sculpts the extremity of our limbs—our hand first emerges as some kind of unified glove—some kind of fin with five extended branches of cartilage starting from our fist up to the tip of the hand—death will erode the cartilagineous tissues to progressively detach and autonomize each fingers."[100] The embryo is also formed this way, and then your organs and so on.

Death is at work, "cutting and collapsing the supporting connective tissues and bridges in between parts of the organism", "it appears quite clearly that death is a process fully embedded in the continuum of space."[101]

Freud

Death at work.

Alien

Then there "is the death of the organism as such. This death is one which comes to interrupt

the active process of cellular death—blocking the communication between cells and at the same time stopping their proliferation/annihilation process."[102] This is 'your' death—the one we know the most of: and on a cellular level it is a death of the dying, the death of the process of cellular death".[103] A number of new processes begin once the heart stops, the breakdown process; enzymes are released initiating disintegration and decomposition by organisms from outside the body finally renders the body mass one with the soil.

Man is shocked by the break he gets with the image of death, but it is fundamentally meaningless to nature and the universe.

Freud
You mean his conventional death. 'Death death'.

Alien
Yes, well, yes his capital D Death. But 'death death'. Hmmm. Like the death of death?

(*long pause*)

SCENE 16

Actually maybe that's what is most significant about the dream I dreamt, and Joseph Wright of Derby's painting, and Robert Boyle's experiments...

Alien(continues)
In this case, the case of the bird in the vacuum, particularly a vacuum in its most ideal state, such decompositional process cannot occur. The organism is kept "in a kind of perfectly inert stable state where the organism undergoes no change at all."[104]

Freud
"Death at the center of our object", "it is a death of processes themselves, the interruption of all becomings, the advent of radical indifference as that which puts all differentiation to a stop."[105]

Alien
"If the suffocation of birds is a truly important event, it is not because it introduces some kind of difference in the order of beings, but on the contrary, because it brings out the form of indifference itself into our world."[106]

Freud

A human indifference to the world. To stand by and destroy and consume. As individualists.

Alien

Precisely. Humans are an interesting and paradoxical species. On the one hand incredibly powerful, we just need to look at the incredible mark you are leaving on Earth. Its widely anticipated Man will destroy an entire planet, Earth, quite a feet. But on the other hand, the species stands basically immobilized in the face of these transformations.[107]

Your modern, human dominance over nature has been shattered.

Covered exterior. The grandiose AMC Theatre, Times Square, New York City. An ambient soundtrack of busy cabs honking and crowds bustling over the streets at night. Red and yellow neons and tungstens glimmer overhead the Alien and the Curator as they walk arm in arm out of the movie theater. They're still chomping on popcorn that's now pulled from deep within the oversized paper bag, between sharing slurps from the jumbo cola. They lean into, and onto each other slightly and clumsily as they walk with a gay rhythmic gait. The classic theatre signage above them shows a single title, 'Gravity 3D'.[108]

Curator

Hollywood at its best really. The 3d was even great. What do you think?

Alien

I think its brilliant. Conceptually. Formally, also really well done.

Curator

Really?

Alien

It's the seminal science fiction for this generation.[109] The most important in the genre since 2001 A Space Odyssey in the late 1960's. The film captures the zeitgeist of man's position in this period of anthropogenic shock.

The Curator unlatches herself a bit from their mutual grasp, giving the Alien room to gesticulate and looks on interested as they fluently surf, splitting through the Times Square crowds.

Alien (continues)

In the 1960's Stanley Kubrick captured the modernist spirit at the peak of man's optimistic philosophy.

Curator

Optimistic and maybe delusional...

Alien

With 2001 A Space Odyssey we get, a kind of bizarro evolutionary image. Also brilliantly done. The picture begins with the 'dawn of man', and the moment of violent transition from Australopithecus boisei to Homo habilis[110] as the species discovers tools. Then, with a great cinematic cut we enter the phase of Man at its most advanced and powerful, Man in the year 2001. Here humans and technology enter a struggle that drives Man into the void. From here we witness the distortion of how Man as subject, perceives nature. Through our gaze we experience the new conceptions of science put forward in the era, with mind-bending results, the plasticity of time and space. Finally the powerful conclusion of the journey is put forward with man emerging as 'the Starchild', Man's transcending rebirth into the universe with powerful optimism and dexterity towards a modern mastery of nature.

SCENE 17

Kubrick holds a mirror against his generation and captures in its representation the philosophy of the era.

The Curator giggles a bit and smiles with her eyes interestedly, enjoying and encouraging the analysis.

Alien(continues)
Gravity. Every character is in constant struggle to evade the void, and death by suffocation in the vacuum of space. The void is relentless and all-powerful, the breadth of the film is essentially a single action sequence, it just keeps coming and coming. Man is being expelled by the universe, at every possible turn; there is zero safe ground except a singular sanctuary, Earth. This is all Man has. Human life enters a virtually alien relationship to the planet. The single survivor goes through a series of apparent rebirths throughout the film, but there is only one true rebirth, pummeled towards the earth, she rematerializes into the sea. Here we get another picture of evolution, this time Alfonso Cuaron accomplishes a few millions years in about two minutes of screen time. She symbolically moves through phases, the Paleozoic fish swimming out of the depths and towards land. Into another phase,

The Human Alien to Earth

crawling out of the slime and muck, pulling herself along with unaccustomed limbs. Then another, struggling from on all fours, she enacts Man's first step, evolving as she erects her human body. Her environment is surveyed again, for the first time. After a few uneasy steps her symbolic journey ends as she reendows her body in the present, and reenters the world with a new view of nature and the universe.

Curator

Love it. Kind of the beginning of a 'dark enlightenment.'[111]

Alien

The dark enlightenment. At the dawn of the anthropocene.[112]

An Alien Odyssey to Creative Freedom: Towards a Theory of Artistic Research; from the Abstract Maybe to the Concrete Real

Brendan Michal Heshka

Interior. Psychoanalyst's office. Early morning. The two, Analyst and Curator sit face to face, each holds a steaming white Styrofoam cup of black coffee. We sit with them for an awkward minute of silence, a silence that the Curator tries to pass off as not being awkward, and finally caves into—

Curator

Ahhh. I guess, I thought I'd like to talk about some of the things we're working on right now.

Analyst

Oh. You'd like to talk about work?

Curator

Yes, I mean. I thought it would be good to work out some things here. You think it's unusual that I always want to talk about work?

Analyst

I don't think it's unusual.

Curator

Well, everything is going pretty good, really. The only thing I've really been stressing about is making the work for this show. And I guess I'm under pressure, maybe mostly from myself.

Analyst

Mmhhmm. Have you arranged another space, now that you guys won't be showing in the Chelsea district galleries?

Curator

Well actually, it's pretty clear to us that we can't possibly use a gallery to accomplish something relevant, new, or at all significant. This exhibition will not be like any other exhibition; it will be "different in an important way from preceding art shows."[113]

Analyst

Yes, following what you've been saying it seems like this project has that potential. Has a set date been established?

Curator

Ahh, no. I guess not. We're focusing on the work—
(*trailing off*)

Analyst

No deadline? Oh. More a series of goals and scheduled points of arrival then?

Curator

Well. Of course. But. In a way no, not really, it doesn't seem necessary to follow that kind of... with this project and ... ahhh—

Analyst

Mmmm. This exhibition may not require a given place or specific space, most likely there will be no demand for display, perhaps no objects. It sounds as though it may not necessitate a certain time of commencing, or have a duration.

The Analyst gesticulates as he delivers the interpretation removing his glasses by the temples of the frames and brings them to rest at a point with his pursed lips, in the classical intellectual gesture. Silence.

Analyst (continues)

not really an art show is it? Which is not meant— and does not discount the work in the slightest.

Curator

Ok, Yes. I guess. Perhaps it's not an exhibition, but maybe it's just but another opening up or flattening of another term and ideology behind it.

Analyst

Hmmm. As your developing this work, this project,

remaining as a condition of its development, is, that the realization of this work, will meet an audience, have a viewer, be completed via spectatorship...

The statement is left open ended. The Analyst leans in, turning his ear towards the analysand as if gently demanding response, then resting his gaze at the window while the Curator considers possibilities put forward.

Curator

Well. We're beginning to question just that relationship, between object and subject. "Contemporary philosophers have pointed out that the present moment is distinguished by a prevailing condition of groundlessness. We cannot assume any stable ground."[114] Linear conceptions are being usurped, there is a kind of total flattening process at work. No more trajectory of say, modernism into post modernism, into a post post modernism, but a stasis of meta modernism, with layers or particles of unbound theory and ideology floating and colliding in a kind of gravity-less state. We—

Some silent moments of contemplation pass.

Analyst

We?

Curator

Yes. It has definitely become a collaborative work between Myzeritteus Mêtis and myself.

Analyst

The alien?

Curator

Mhmm. Yes. The artwork we're developing must face that there is no longer the necessary grounding to presuppose that the object must be subordinate to a subject. The sufficiency of both art and science has become suspended in their grasp of the real[115]. Contemporary art however, remains under an ideological regime safeguarded by the institution and insulating layers of counter revolutionary history.[116] Contemporary art is a neoliberal project, presupposing the human subject as independent from and with priority over the object[117]. We are working towards the possibility and necessity of non-anthropocentric art forms.

Analyst

This perspective for you, arises from working with a symbolic non human entity on this project. You're trying to split away from your position, and imagine how it could look from this otherworldly,

figures outside positioning. An attempt to escape some human nature by alien metaphor.

Curator

No. Actually it comes by looking at our human position more closely, not escaping it. And considering closely human nature towards nature. Actually it's both spectacular and horrifying. Witnessing the current ecological state of the planet synthesizes feelings of fear and awe. This epoch is defined by the final observation that Man is osmotically penetrating and permeating nature. Human nature actually becomes nature, and nature becomes human nature. The great divide is no more.

The Analyst looks on listening, however he does not hang on the Curators every word and does not share in any excitement by way of what she says. He uses free-floating attention, attentive, but without latching on to particular statements, without etching every connecting detail into mind, and thinking it through.[118] *Without being seduced by the words and enthusiasm the Analyst continues the attempt at approaching the real of the Curator's story, like an archeologist working to uncover and unearth the true artifacts of the chronicle. This free-floating attention however looks like boredom; the psychiatrist appears to be in a state of indifference. A few silent moments pass.*

Curator(continues)

Is this crazy?

The Analyst props himself up slightly in the chair. Shrugging off a response to the question with a movement of his shoulders, a facial expression and a twist of the head, the query is put back to its asker.

Curator(continues)
Well.

(long pause)

I watched this film the other day. Documentary on a photographer,[119] *Chasing Ice*. The artist is studying the diminishment of the polar ice caps; he's not using numbers or statistics or rhetoric to demonstrate this, but a straight representational visual aesthetic. More powerful than all these abstract calculated warnings of global climate change, we see with our own eyes. It's like watching half of Manhattan Island heaving and crumbling into the ocean, as these massive mountains of ice shear off the frozen glacial continent devastating the landscape. It's Sublime. Paralyzing, you can actually feel the horror being materialized in your thoughts, then coursing down through your nervous system and into your veins.

Some silence.

Curator(continues)
Also find this, kind of, 'anthropogenic sublime'[120] in Edward Burtynsky's photographs. Colossal,

awe-inspiring, foreboding, human manufactured landscapes. Nature once stood aloof in its vastness and grandeur, now it is fundamentally shaped by our own human action.[121] The anthropogenic sublime, really powerful images, that change everything. As the anthropocentric image towards the human supremacy over nature is shattered, human beings simultaneously transcend into nature itself, ungrounding the moment of enlightenment three hundred years earlier.

"The thought of the anthropocene opens us up to an ecological understanding of the world which unitlaterlizes the distinction between figure and ground. Or the subject and object. There is no privileged viewpoint from which to stand."[122]

The two sit in silence. Mary is calm and considerate in her state of contemplation; it is this time the Analyst who twists and shifts a bit unsettled.

Analyst

Hmmm.

Perhaps it may be advantageous, if you'd like to continue talking about your work exclusively here, that we invite your collaborator into these sessions?

Mary continues to stare out the window. We slowly push out this window and into the beyond of her view. Warping through time and space, we begin to settle our gaze into another window.

Art Under the Condition of the Anthropocene

CUT TO:

The Alien sits in the large pitched lecture hall of the Professor. Myzeritteus Mêtis in the front row, alone and directly in front of the Professor who speaks, standing over a table separating the two, and with the backdrop of a blackboard covered with heavily erased traces of past teachings and diagrams.

Alien

"I think therefore I am."

Professor

Yes yes yes of course! But when Descartes says "I think therefore I am," we must read this in light of what we now know as the unconscious! "What Descartes is concerned with is the Ego, the thinking thing that is the human subject as entirely transparent and transcendental. "I am thinking, therefore I am, "that is, insofar as I think, I am—absolutely. We can add further: *cogito ergo sum ubi cogito, ibi sum*, "I think therefore I am, where I think, there I am," or perhaps better still, "I think therefor I am... where I think I am" both in the sense that I am where I think, but also I am only where I think I am in the illusory sense of merely thinking it."[123]

Alien

"This limits me to being there in my being only insofar as I think that I am in my thought."[124]

Professor

"To take Descartes at his word is to deny the psychoanalytic work of the unconscious, that there is at least a part of me, perhaps the only part that is truly 'me', that escapes my thinking, that in fact only shows itself, only has being, when I am not thinking." For this reason, in the light of the truth of psychoanalysis, we must propose a re-reading of Descartes and transform the Cogito. The foundational phrase becoming 'I am thinking where I am not, therefore I am where I am not thinking.'"[125]

Alien

"I am thinking unconsciously in the void in my being, therefore I am most myself there where I am not thinking at all."[126]

Professor

Or "I am not, where I am the plaything of my thought; I think about what I am where I do not think I am thinking."[127]

Alien

The subject existing outside of his subjectivity...

SCENE 19

Interior. Newark Liberty International Airport, New Jersey. Dull, excruciatingly dull, background, foreground and mid. Flat and grey. Identical commercial choices surround. Uniform and interchangeable to any bad airport in the western world. Myzeritteus Mêtis stands, giving the odd pace and twist of direction at random, appearing to be in a kind of stultified trance. Any person, plane, shop, furniture, or architecture could be substituted for another. Here nothing emits consequence, not even the people who rush around as if they are so important and the balance of the world depends on them catching their connecting flight to Sacramento, Topeka, Milan, Zurich or London. A wide view of the arrivals area, the focus pulls to the background where we see Mary, the Curator board the escalator in the distance, then gradually approach without cut towards and behind Myzeritteus Mêtis as he gazes out towards the jet tarmac beyond, but focusing on some somewhere in between.

Curator

Myzeritteus. Myzeritteus!

The Alien is shaken out of his distant trancing by the words and then the touching greeting of the Curator.

Alien

Hello! Mary!

Quite stunned, surprised and happy to see his partner.

Alien

It's so nice to see you. How was the symposium, and Zurich?

Curator

Ahh, it was actually really good. They took pretty good care of us. It was nice.

Alien

And ?

Curator

Yeah, I'm just exhausted. Let's not get into detail right now, I'll tell you about it when we get home and I'm settled again. What have you been up to while I've been away?

Alien

Well, I've been here.

Curator

Of course, but what's up? What have you been working on?

Alien

No, I mean I've been right here since you left.

Curator

What? You mean you've been waiting here at Newark Liberty International since we said goodbye at the gate Sunday night?

Alien

Yes.

Curator

Jesus. Serious? That's sweet but kind of weird isn't it? I couldn't think of anything more boring. You must be bored out of your mind, are you ok Myzeritteus?

The curator is concerned and puts her hands around the Alien's face, scanning deeply with concern. She gently eases Myzeritteus down into the closest chair and kneels at his feet.

Curator(continues)

You've been here since I left?

Alien

Yes, but I've been working. Hard. I'm attempting to "break out of this eternal cycle of function."[128] Surrounding all this productivity (*gesturing to their surroundings; the people rushing by, the stores and restaurants, the airplanes and finally to the waste and recycling bins*), hidden behind, is a tremendous, tremendous amount of waste. "Maybe we shouldn't try to get rid of it. Maybe the first thing to do is to accept this waste, to accept that there are things out there which serve nothing."[129] Time is not money. I need to waste my time. When engaged in all this, all this production, all this waste, we cannot see what is truly at stake, we

cannot see what it means.

Curator

Like history, we need to step out of experiencing it, being engaged with events and things, to intuit what it might mean, for it to literally become history.[130]

Alien

There exists a mute presence beyond meaning that can be expressed in psychoanalytic terms as the inertia of the real.[131] I need to confront this by observing, as an example, this airport, with all its production and hidden waste with the widest scope possible. I can employ boredom to see what's really going on here and to escape the trap. I need to provide myself the chance for an authentic passive experience. "Maybe without this properly artistic moment of authentic passivity, nothing new can emerge. Maybe something new only emerges through the failure-the suspension of proper functioning of the existing network, of the life work, of where we are."[132] "Boredom's revolutionary promise lies in its capacity to dispense with the often mistaken convictions and assumptions which give meaning to our lives, and to require us to face the fundamental question: how should we actually spend our time?"[133]

Curator

Maybe this nothing, this boredom is what we need more than ever today!"[134] To break from the spell of the commodity.[135] Maybe boredom's residual traces have "the potential to undermine the hallucinatory power of the commodity and awaken us from the 'dream-filled sleep' of capitalism."[136] Perhaps the quintessential experience of modern life.

Alien

"We are bored when we don't know what we are waiting for. That we do know, or think we know, is nearly always the expression of our superficiality or inattention. Boredom is the threshold to great deeds."[137] "The old habit, of associating a goal with every event... is so powerful that it requires an effort for a thinker not to fall into thinking of the very aimlessness of the world as intended. This notion—that the world intentionally avoids a goal—must occur to all those who would like to force on the world the capacity for eternal novelty."[138]

Curator

Maybe though, boredom is paradoxically productive, as it "provides access to half buried memories, missed historical opportunities and revolutionary

possibilities."[139] "The value of boredom is that it can form the beginnings of an awareness that the dull monotony of the present will only end with a resolution of the deeper contradictions of society, and the creation of an alternative society based on true creativity and pleasure."[140]

"Boredom is always at the external surface of unconscious events."[141] "Boredom is the warm gray fabric lined on the inside of the most lustrous and colorful of silks. In this fabric, we wrap ourselves when we dream."[142]

Alien

"We are at home then in the arabesques of its lining. But the sleeper looks bored and gray within his sheath. And when he wakes and wants to tell of what he dreamed, he communicates by and large only his boredom."[143]

The Alien and the Curator have shifted their attention away from each other, they now gaze out the wall sized windows as the planes come and go with great force and ease as the sun begins to set causing an orange, pink and purple effect on the sky. Some time passes, and they seem to settle into the frenzied setting.

Curator

Did you know that "In 1757 there were only three cafés in Paris?"[144]

Alien

Hmmmm.

The last bit of the fire orange sun fades into the horizon of the New Jersey tarmac.

Alien(continues)

The work is almost complete. We have almost accomplished our project Mary, our artwork is near finished.

FADE INTO:
~~~~~

*Interior. Analyst's office New York City. The Curator has graduated to the couch, and occupies a prone and dreamy position. The Analyst now sits beyond her view, and has a pad and pen in his grasp, he maintains a blank expression but it seems to slightly reveal an air of skepticism.*

**Curator**
"It is dreams that constantly remind us of freedom. Dreams give us impulse to distrust all necessity, to despise the iron rule of the status quo. In dreams I have tasted blood. Dreaming, I become aware of possibilities that reality denies me over and over again."[145]

**Analyst**
Dreaming freedom.

**Curator**
"The first step to freedom is not simply to change reality to fit your dreams, but to change the way you dream."[146]

**Analyst**
Hmmm, to change your dreams.

**Curator**
This will obviously hurt, and shock. Because all our satisfactions come from our dreams.[147] We must

change our dreams to escape the deadlock of the constant crises of capitalism. Our radicals so often still dream the capitalist's dream. And fall flat once they've attained their most far-fetched desires. Individual desires and dreams for success. Marina Ambrovovich. Of course, it must hurt to be a revolutionary, but you must start by hurting yourself.

*Entering the point of view of the curator. The room is observed through a slightly glazed perspective. She scans across the various artworks, sculptures, paintings and photographs that adorn the office, gently searching for a place to rest her gaze while lost in thought. Her eyes settle and explore the various abstract and interpretable details of the ceiling, which become simply as interesting, as abstract, and as figurative as the conventional art bedecking the office.*

**Analyst**

Is this encompassing narrative, your narrative, a great dream? This figure of the alien a construct that you employ to free yourself from the regimes of the art world and the greater cultural landscape, from the vanity of the arts, sciences and philosophy?

**Curator**

"Must the sun therefore murder all my dreams?"[148] Dreams have interests that do not coincide with the living, escaping the traps of necessity, of a

subjective death; we can stand outside but still inside, and witness, and observe our multiple deaths. Here we find freedom from the impossible, to experience our mortality, escape all and any singularities, to travel and twist through inconceivable spaces, to participate in nonlinear time warping, repetitions, breaks, stalls and cuts. To leave our bodies, enter others, become anything, everything is possible, to be discovered and brought into our waking realities. We can shape our future only by shaping our dreams. They always lead.

*Interior. Curator's Apartment. Formerly lavish and carefully organized and curated living room has been turned into a kind of strange hybrid studio space. Books, documents, notes, diagrams, images, maps, charts, figures, calculations, aerial photographs, studies, paints, models, cameras, printers, screens, projectors, speakers, monitors, computers, and more computers. The Alien is projecting from this station, casting a large image onto the white wall that's has been emptied and cleared. Myzeritteus is watching the final speech of former Romanian dictator Nicolae Ceausescu. Pausing and rewinding the video, investigating key moments, studying the 1989 revolution. The volume is cranked, and the jeers and whistles and boos cut across the speech. Mary enters the scene, curious, drawn by the violent and dramatic sounds.*

**Alien**

```
Mary look. Look. You can actually see the precise
   moment when Ceauşescu cracks and discovers his
  power has been rendered empty. The cut, that opens
      up, to end the regime. The mass crowd suddenly
    and collectively no longer accepts the dictator
     as their master, his power decimated and rendered
      hollow by the momentum of revolution, culminating
      in the violent storming of the formerly imposing
                    architecture.[149]
```

*The alien manipulates the video back and forth and captures the precise moment written on the former leaders face, accompanied by the violent jeers and howls beyond the image that reveal the collapse of his power and control.*

**Alien(continues)**

```
  Watch. Here. "The rebels waving the national flag
    with the red star, the communist symbol cut out,
```

Dictator's loss of dick

so that instead of the symbol standing for the organizing principle of the national life, there is nothing but a whole in the center."[150]

**Curator**

Sublime. The perfect symbol for their revolution. The void. Emptied.

**Alien**

The void of the revolution's "intermediate phase, when the former master-signifier, although it has already lost the hegemonic power, has not yet been replaced by the new one." "For a brief, passing moment, the hole in the Big Other, the symbolic order, became visible."[151]

**Curator**

The masses experienced a true openness.

*Myzeritteus turns down the volume and lets the video run and loop. And the Curator takes a seat amongst the organized mess.*

**Alien**

Ideology becomes our spontaneous. It is not simply imposed on us but becomes us. To step out of it hurts, it's a painful experience, you must force yourself to do it, this leap is rendered through a violence.[152]

There is an extreme violence to liberation. You must be forced to be free. If you simply trust your spontaneous sense of knowledge, of feelings, of whatever, you will never get free.[153]

**Curator**

Freedom hurts.

**Alien**

"Every violent acting out is something you are not able to put into words, even the most brutal violence is the enacting of a certain symbolic deadlock." "Violence is never just abstract violence, its a kind of brutal intervention in the real. To cover up a certain impotence, concerning cognitive mapping-you lack a clear picture of what's going on—where are we. All this violence is basically suicide."[154]

**Curator**

Working with violence. Violence working.

**Alien**

Yes. "You should have the outburst of violence, but you should direct it at yourself. In a very specific way, at what in yourself, chains you, ties you to the ruling ideology."[155]

**Curator**
"You kill people around, you end up killing yourself."[156]

*Myzeritteus slowly pulls this Earth body out of the mess, holding this thought and carrying it toward the windows and view of the great city below—gazing deeply and outwardly inside the mind.*

**CUT TO:**

*Still within the apartment. What was formerly Mary's dining room has been transformed into a version of the white cube gallery space, emptied of all furnishings, decoration, and artificial lighting. The room is now sealed off completely at its open end, adjacent the floor to ceiling window, with a thick clear plexi-glass material. There is an intricate series of air lock doors constructed into the plexi-glass wall at different scales, a pump runs, humming constantly connected by clear tubing that seems be sucking the air from the gallery chamber creating a vacuum within? A number of sensors, cameras, monitors, wires, switches and panels make up the rest of the details pinned to the sterile cube. Kind of a cross between an operating room, NASA, and the Whitechapel gallery.*

................................................

*The Alien prepares a selection of objects that are being launched into the space. First a book that settles open with its spine facing the skylight above, something by Gombrich, it looks like the 1950 first edition of the Story of Art. Next an iphone slides into the space along the sterile fake hardwood floor. Followed by an A1 of unexposed glossy photo paper, floating down from the highest trap door. A medium scale sculpture enters, and is then damaged as a medium scale white plinth collides settling on top of it. Some indiscernible chemical or vapor is incorporated into the chamber, at a timed interval is followed by a thick black resin that pools and puddles connecting the iphone with the large art history text. A bell sounds, a folded steel chair, ding, another bell, a large fish slides across the floor, maybe a wild salmon. Ding, a giant lump of raw clay. Ding, the next bell Myzeritteus blares Beethoven's Ode to Joy into the chamber before the next bell signals the air locks closure and the music to cease. More intervals. A series of small spacey robots are released into the gallery, causing seemingly random collisions and interactions before exiting at the next bell. The Alien runs a complicated choreography, monitoring, and triggering, orchestrating and observing the work as it develops. All this takes many hours.*

................................ **CUT TO:** ........................

SCENE 23

*Much later. Much much later. The work has been removed from the gallery vacuum and the space appears again spotless, white, and sterile. The cacophony of objects, equipment and materials that occupy the apartment, now studio workspace, have been given order into stacks and aligned in organized sequences and storages. A presentation setting has been erected, like a small boardroom, ready for lecture. A few computers remain active and a few thick, neatly bound pdf documents rest on the table. The Curator and the Alien work, presenting side by side their artist-talk lecture, to a small but significant audience that also includes a recording camera, the guests as judged by appearance but preceded by the impossibility of time and mortality, Marcel Duchamp, Joeseph Beuys, Alan Kaprow, Peter Higgs, Sigmund Freud, Slavoj Zizek, the Professor Jacques Lacan, and of course you. Most of whom smoke, and all of whom silently follow. Or don't follow.*

*The artist talk:*

**Curator**

We would like to begin by shaking the ground. And instituting a new discourse for art, one without humans at the center. An artistic Copernican revolution, a theoretical tooling-up to redeem art from the hegemony of the ruling Artworld. And in so doing, finally catch art up to the de-anthropocentrism that has already long been established in the discourses of science and philosophy. We ask can art exist after the impeding extinction of the human race, or does it mutually vanish. We would like to propose the possibility of both people and art remaining after this imminent human extinction.

**Alien**

From my research and observations the single greatest regime in the world of art, is the belief that humans still make up the center. Contemporary art maintains the Humanist proposition that objects are subservient to subjects. Let me explain the position that renders the necessity of a post humanism approach.

In the face of the Anthropocene, humans and nature enter a paradoxical relationship; humans no longer stand separate from nature but make nature. In the previous geological epoch, the Holocene, humans were under the injunction of the earth, relying and adapting to its conditions for survival, but in this current era man adapts and imprints humanities conditions on the earth. However, simultaneously, and in precise conjunction with this shift, human survival itself is pushed towards impending extinction, mutation and metamorphosis as humans stand virtually powerless in the face of their global changes. The ultra thin layer between humans and the world dissolves, ungrounded the human subject sinks into the materiality of nature and vice versa. The anthropogenic shock produces a melting together of the human subject and the object of the world

effecting a philosophical flattening of the ontological.[157] Leveling the very nature of being. There becomes no constitutional relationship between the subject and the object[158] as the two positions swallow each other. The undoing of the figure-ground relationship in art.

What does this mean for art? Can art withstand a shift away from the anthropocentric? "The Anthropocene demands new modes of modeling arts relationship with the real" as all previous regimes were grounded in a now eclipsed given concept of nature.[159]

**Curator**
Placing humans and objects on equal footing degrades meaning. But there exist underexplored meta layers of interactions between forms, symbols and signs, that exist below, above and around meaning in the 'entropic gray-goo'[160] muck somewhere between the symbolic, the imaginary, and the real. This decentering of the human in art, science and philosophy opposes the anthropocentrism of Immanuel Kant's Copernican Revolution, whereby objects are said to conform to the mind of the subject and, in turn, become products of human cognition.[161] Objects exist independently

of human perception and are not ontologically exhausted, defined or completed by their relations with humans or other objects.[162] All relations, including those between nonhumans, distort their relata, that potential held by the object to be related to, in the same basic manner as human consciousness and exist on an equal footing with one another.[163] "Objects become full, autonomous participants in the cosmic drama right along side us. Humans are not 'up ahead' of objects in general, not the leading edge of evolution; neither are they any closer to Being than every other being."[164] Humans exist as difference—making beings among other difference—making beings, therefore, without holding any special position with respect to other differences.[165]

### Alien

What is then, also at stake here, and changes, is the contemporary art requirement for the position of the spectator to complete the artwork or art object. In effect, situated within the anthropocene, we overcome the repetitive regime of the Readymade, where the privileged artist performs the gesture of continuously bringing art or nonart into the safeguarded institution to be interpreted by a subject as the cite of meaning production.[166]

**Curator**

And do away with contemporary art's local field of apolitical openness that makes a universal appeal to the viewer to coproduce a meaning under the doctrine of the inclusive institution that safeguards the work from the radical outside.[167] Within the institution of contemporary art exists a pre-negotiated openness to the individuals refinement of meanings stemming from the indeterminate nature of the artwork.[168] In effect nothing is at stake in the handling of what's outside of the artwork. An almost anything—goes, subject only to the competence, refinement and taste of the spectator. "The outside is nothing but an environment which has already been afforded as that which does not fundamentally endanger either the survival of the subject or its environing order."[169]

**Alien**

But, under the present conditions, culture is dissolved into nature via the incorporation of the subject into the object.[170] And the outside becomes the inside and the inside the outside. "The anthroprocenic shock forces thought to confront the ecological conditions beyond the subject—and this can only be achieved by

presupposing the radical immanence of materiality. Yet contemporary art disavows the radical immanence, instead relying on the specular production of individualized active subjects. This specular operation acts as an immunizer by producing meaning only for its subject. By de-immunization to the antroprocenic shock art can produce subjectivity through its inter-interdependencies and consequences rather then the fantasy of universal rights upon which contemporary art is based."[171]

*You are not getting bored.*

**Curator**

We continue to explore the creationary violence of the colliding agency of forms, signs, and symbols but focus this project on a shifted object of subjectivity that arises from our work. An art "model for instituting a non-human, that is a non anthropocentric, non human centered democracy, beyond individual autonomy."[172] We shall reorient our thinking on the position of the 'human thinking and being'.

**Alien**
"Humans are a complicated biological species," however "this is not to assert that humans occupy a special place in the world. It is actually sapience, the ability to think, which is privileged in the place of the human." "Rational thought is not the exclusive domain of the human," but "a procedure that can be instantiated in substrates which are not just human beings." [173]

**Curator**
For example. The sapience of the extended mind of social assemblages—the social condition. Socio-technical networks—platoon like thinking where technical components mediate thoughts. Developing potentially, artificial intelligence—say rationally thinking machines.[174] And extraterrestrial life forms—introducing alien modes of cognition.

**Alien**
Effectively dethroning the humanist idea of the human being.[175]

**Curator**
The anthropocene, like Egyptian sculpture, "celebrates human presence while acknowledging the

eventual demise of that presence,"[176] foreseeing the post-anthropocene to follow. "We are brought to this Anthropocenic precipice not just by a cosmic predicament but by the tempestuous, ambivalent violences of Capitalism, particularly our current Algorithmic Capitalism. This economics is, on the one hand, the megamachine of incredible anthropocentric composition and consumption, and on the other, the appropriation of planetary matter, including human flesh, without concern for politics or limit, by an intelligence from the future. Capitalism is seen at one and the same time as a compulsive eco-economics linked inextricably to our omnivore dominance, and/or an alien entropy machine for the processing of terrestrial material, value, and information into absolute speed, peeling back the husk of human markets so as to finally suck dry the complicit mammalian diagram. To eat or to be eaten?" "The poverty of our future is not a poverty of the future."[177]

### Alien

"The post-Anthropocene foreshadows and foregrounds the eclipse and extinction of Anthropocenic anthropology," "it establishes not only that humanism disappears with humans, and vice versa,

but that the more elemental genetic machines with which we now co-embody flesh can and will, in time, re-appear and express themselves as unthinkable new animal machines, and with them, New Earths."[178]

**Curator**
"Our species may simply go extinct, making way for some as yet entirely unimaginable adventure in creativity upon the Earth. Perhaps machines are awaiting the nuclear disaster that makes most organic life on this planet impossible, just as mammals once hid in the shadows of the dinosaurs to await their chance to rule the world."[179]

**Alien**
This futural spectre corresponds to a post-capitalism as it foretells the ultimate completion of capitalism's historical mission.[180]

**Curator**
"When it comes to devising an actionable ethical response to an increasingly inevitable natural/ecological catastrophe,"[181] the danger of all this ungrounding, is to stand, or rather fall paralyzed in the wake of reason.

**Alien**

Here it comes. We're almost there—

**Curator**

As the vision of a clockwork deterministic universe, where we can predict and posses all the sufficient information for mastery within the laws of reason is rendered abstract, empty and void, we can however look to the order of chaos for designs on escaping the trap and form new modes of mastery.[182]

**Alien**

"A project, ultimately, of freedom."[183]

**Curator**

Chaotic systems are far from being totally indeterminate. Chaos actually has large-scale rules, delivering an intelligible randomness, which actually creates order out of chaos, with included regularities hidden within chaos systems. We can develop modes of mastery within chaos where we do not precisely know what will occur, but what does occur will be drawn from a relatively limited range of possibilities. Whilst we can't predict the precise results of our actions, we can determine probabilistically likely range of outcomes.[184]

SCENE 24

**Alien**

This brings us to formulate, define, and employ a strategy that is particularly useful in facing the complexities of chaos which thwart an explicit decision making process.[185] "A new form of action: improvisatory and capable of executing a design through a practice which works with the contingencies it discovers only in the course of its acting."[186] Mêtis.

**Curator**

Mêtis is an ancient Greek concept. A mode of cunning in craft[187] or a "skill with materials guided by a kind of cunning intelligence." "The ability to coax effects from the world, rather than imposing effects on it by the application of force alone. Following the grain of wood, knowing the melting points of various ores, the toughening of metal through its tempering: all these are not domineering strategies, exactly, but situations"[188] "in which the intelligence attempts to make contact with an object by confronting it in the guise of a rival, as it were, combining connivance and opposition."[189] "Mêtis holds an important position within the Greek system of values, it is never made manifest for what it is, it is never clearly revealed in a theoretical work that aims

to define it. It always appears more or less below the surface, immersed as it were in practical operations which, even when they use it, show no concern to make its nature explicit or to justify its procedures."[190]

**Alien**
"There is no doubt that mêtis is a type of intelligence and of thought, a way of knowing; it implies a complex but very coherent body of mental attitudes and intellectual behavior which combine flair, wisdom, forethought, subtlety of mind, deception, resourcefulness, vigilance, opportunism, various skills, and experience. It is applied to situations which are transient, shifting, disconcerting and ambiguous, situations which do not lend themselves to precise measurement, exact calculation or rigorous logic."[191]

**Curator**
"Mêtis is characterized precisely by the way it operates by continuously oscillating between two opposite poles."[192]

**Alien**
Two poles, thought and non—thought. An artistic

space between concepts and precepts.[193] This mode of artifice through devious and well-timed action, brings into play the dynamic tendencies of the materials it works on in an improvisatory fashion, a moment by moment awareness and exploitation of the material being worked (again, the term material remains defined in the widest sense). Mêtic practice entails a complicity with the material, a cunning guidance of the contingent, and unknowable in advance, latencies discoverable only in the course of action."[194]

### Curator

An "intelligence which operates in the world of becoming, in circumstances of conflict—takes the form of an ability to deal with whatever comes up, drawing on certain intellectual qualities: forethought perspicacity, quickness and acuteness of understanding, trickery, and even deceit."[195]

*Myzeritteus surveys the audience who* **CONTINUE TO FOLLOW!** *While pouring a glass of water for the Curator, who takes a moment to consume its contents lubricating her instruments of speech.*

### Alien

There are six billion years of energy left at the center of this solar system and the human peoples

have the potential to participate in that time intelligently.[196]

**Curator**

So how can we escape this trap that we've constructed for ourselves? This accelerated plummeting destruction of humanity on Earth.

**Alien**

"If setting and escaping from a trap implement the same logic, to be prey is an education in how predation operates."[197] "In order to anticipate the reactions of his pursuers, the hunted man has to learn to interpret his own actions from the point of view of the predator: seeing himself in the third person, considering, with respect to each of his acts, how they might be used against him."[198] The anxiety can later be transformed into a kind of chaotic reasoning. "This process tutors a view of oneself as in part an object, and converts this knowledge into an active resource."[199]

**Curator**

a practice in the operations as a, kind of, 'con-artist', a process of flipping the game.[200]

SCENE 24

### Alien

If the people of earth want to 'be', as in maintain being, through this epoch. They must be unlimited in their thought and non-thought. Must think and act outside and between themselves, think like the earth and against the earth, think like nature and against nature. Act like the sun and against the sun. Act like the climate and against the climate. Think between the dead and the living. Work with science and against science. Work as artists and against art. Form a new kind of praxis of geo-social artistry.[201] Humans must think and act beyond their greatest common nemesis, death, for thought "has interests that do not coincide with those of living."[202]

### Curator

We must not let death limit our thinking but introduce death into life.

### Alien

"Death is a property, a condition," "but not a quality without which man ceases to be what he is and what he ought to be."[203]

### Curator

"Nature is not our or anybody's 'home'."[204]

*Myzeritteus eases in a calculated smoothness towards the black drape curtain that covers the full floor to ceiling window behind them and opposite their audience. The Curator rises to her feet.*

### Alien

"Instead of locating the post-Anthropocene after the Anthropocene along some dialectical timeline, it is better conceived as a composite parasite nested inside the host of the present time, evolving and appearing in irregular intervals at a scale that exceeds the Eros/Thanatos economy of the organism."[205]

### Curator

"Either way, the best of all possible news is that, should 'we' survive the Anthropocene, it will not be as 'humans'."[206]

*Myzeritteus begins to pull back the curtains that have been blacking out the outside world and daylight begins to pour into the room at first blocking the field of vision with whitelight as the eyes quickly adjust.*

### Alien

We present you our artwork...

*Meanwhile.*

*Interior. Psychoanalyst's office, New York City. Tuesday morning, 10:31 am. The Analyst is seated at his desk going over paper work. His watch catches his attention, and he holds, gazing into its face, deeper and with much more length then required to gauge any time. The Analyst pulls the telephone along the desk and reaches for a black leather daybook, opening it precisely to the necessary page and transcribing the numbers from the sheet into the keypad of the telephone with a certain directed smoothness. After many rhythmic rings the call connects to an automated voicemail.*

**Analyst**

Oh, hello Mary. Hmmm yes. We were on for 10:15 as per usual, Tuesday morning. It's now 10:31 please call me back at the office and let me know your circumstance and whether you're on your way. Mmhmm Ok. Thank you. Goodbye.

*Sometime later. 11:01 am. The Analyst stands before his window with his arms crossed deep in thought. 11:09am, the sky is overcast and the sun is blocked out covered in a haze. 11:16am, he begins to retake his position at the desk removing a file from the black vertical cabinet, tossing it flat and taking a posture hovering with pen, over a yellowish pad of cheap paper, and sits.*

*Analyst (in writing):*

*Tuesday, September 6$^{th}$ 2016 – 11:17am*

*Mary fails to appear at analysis today. This absence is counter to her normative approach over time, strictly adhering to our scheduled sessions without waiver (and communicating the recognition of her tardiness or absence by a standard remorseful phone call). However this absence has not simply appeared beyond my field of expected probability. I have been monitoring Mary quite rigorously over our last year of analytic work together since the appearance of the 'alien'*

in her narrative, early July of last year. Mary has always maintained high functioning under the diagnosis of normal hysteric neurosis. I have been treading carefully through our sessions in an attempt to discern a notable transition from her neurotic tendencies to a borderline possible psychosis with the arrival of this 'alien' element into her life story. While highly unlikely, I have been careful not to outright classify these 'alien' aspects of her story as absolute signifiers of hallucinations, the hearing of voices, and pure psychotic delusions. It is quite difficult for me to convincingly state through the negations of possible realities that Mary is imagining these things. While, as previously noted, I have requested that this 'alien' join Mary in her sessions, but then even if that were to occur, it would present another necessity to determine the connection between the real and imagined identity of the figure and 'its' symbolic significance. It would be insufficient to diagnose the analysand as psychotic simply by the appearance and persistence of this particular difficult thought. It is impossible for me to determine whether this 'alien' is actually present in Mary's life, and to therefore make conclusions based simply on this information, to say outright, she is experiencing delusions. Rather the certainty with which she expresses this thought (that she does not ever 'wonder' whether it might not be true) and her absolute belief of this without ever questioning or doubting the circumstance or addressing my direct questioning of the 'alien's' existence, drives the analytic diagnosis in opposition to my previous position and towards the schizophrenic. Why is it that Mary never questions the difficult incongruous reality of the 'alien'? How come she is never concerned with convincing me that it is true? This single factor is out of line with her typical accounting of things and normal hysteric desire to place me, the analyst as the capital O Other who is responsible for making sense of her life. Never has Mary attempted to provide evidence for the 'alien's' existence or even acknowledge that it may be a challenging story to believe. While our talk sessions have continued to investigate and question the meanings and symbolic relationships to the Lacanian real, a looking, search for knowledge, this single monumental feature of the telling of her story has remained, for over a year unbreachable, unclear, and fails to be rendered visible by the analysis.

The analyst takes a moment from the unbroken pace of his note taking, to process some thought. The unusual atmospheric haze beyond his window affects and catches his attention for a moment before it is shrugged off with a perplexed grimace, then back into the world of the notepad.

(and continues)

SCENE 25

*Every aspect of Mary's discourse (except solely for the appearance of this 'alien') points to classic neurosis. Where the psychotic personality operates with certainty throughout her discourse, precisely not looking for knowledge, Mary continues with uncertainty and doubt seeking corroboration, validation and assurance. But it shall be noted that over the past few sessions I have observed and marked a gradual weaning of these factors. I have continued to observe the normal slips, couching of statements, and defensive behaviors in Mary's discourse exhibiting the presence of a repressed truth and attendance of an unconscious; factors (repression, unconscious) not present in the psychotic.*

*Again, pointing to normal neurosis, Mary continues to see the many possible different meanings in her speech, to recognize how what she says, the signifier, only relates to what she intends, the signified. She continues to work between the signifier and the signified, in the potential gap of the dimension of language where meanings are formed. Whereas if she were experiencing psychosis there wouldn't be any operation within this division, this gap, her utterances and they're projected meaning would be considered one and the same. The normal performance of this necessary dimension of language would be lost. There has been no observed loss of this symbolic dimension (the unconscious) for Mary, she is not, at least observationally, trapped between the dimension of the imagined and the real that delineates the psychotic.*

*Mary has always been able to situate myself, as analyst in the place of knowledge, maintaining the notion that I have something of value to add, and to know about her. But her failure to attend today may signify a marked change in her position to the capital O Other representative of a world that may know something that she doesn't, and point to her possible termination of this talk therapy work, as deemed necessary or significant.*

*The analysis of Mary's discourse is gradually coming into accordance with that of a schizophrenic psychosis. However as far as I have been able to observe, she still seems to operate within the discourse of a normal neurotic. I will make it clear that these conclusions are not meant to suggest that she is gradually becoming schizophrenic or is at a stage between, in some kind of pre psychosis, but rather that this inability to discern her diagnosis is only a failure of the analysis to, at this point, access the real. For Mary is either telling the truth, and this 'alien' is real, or else she is imagining all of this, and experiencing severe psychotic delusions. From all observational perspectives, their can be no in between, but both possibilities remain entirely plausible, with the one truth hidden behind in the real. The 'alien' either exists, or doesn't.*[207]

*There is no clear diagnosis, beyond Mary's normal neurosis. Everything hinges on the point of the 'alien'. Either the alien exists and she's fine, or doesn't and she is dangerously Schizophrenic. There is no developing or becoming psychotic here, in this case; the Curator is either one or the other. At this point the analysis has failed to render visible the truth hidden in the real.*

# The Artwork

V

> "I create because I know how.
> I know how good-for-nothing I am, that is.
> Art as communication, is the contact between the good-for-nothing in one and the good-for-nothing in others.
> Art, as creation, is easy in the same sense as being god is easy. God is your perfect good-for-nothing."[208]
> —Robert Filliou

The work is present from four different points of instance that interact with one another in time and space, or described more easily with the metaphor—there are four pieces in the exhibition.

*We are back in the provisional lecture room of the Curator's apartment. Gazing out into the vista of the New York City skyline. To the eye, the scene framed by the window seems to preserve the normal, yet exceptional view of the great city. But there is something... Not sure what. Still a bit lost, from following/not following the Alien and Curators artist talk. Outside, beyond this window is their artwork as they've stated. So. Where is it, what is... I don't get it. There is a kind of haze across the entire sky that seems a bit unusual, somehow a bit different from any natural cloud cover, the haze has a slight tint to it, ever slight, a kind of pinkish, purple glow. I don't know, its weird, but what? Both Mary and Myzeritteus continue to stare fixedly out and down. Forgetting this barely peculiar atmospheric mist, this fog, this haze. Attempting to follow what they're looking at, looking closer and closer, and closer. Looking out from high up, the corner of W 88th street and Central Park West Avenue. Out and over the park, across the Jacqueline Kennedy Reservoir. Whoa. The Met is gone! The Metropolitan Museum of Art is missing, left in its place nothing, not even rubble, its just gone, as though it was never there, erased. Quickly scanning the rest of the skyline, things seem ok, seem normal, just this strange haze sitting over the city for as far as the eye can see, wait. The famous Guggenheim is gone! What! Frank Lloyd Wright's infamous spiraling form is missing from its corner on 5th Avenue, its just deleted. Effaced without drama.*

SCENE 26

There are no crowds gathered around the voids left by these institutions, no news crews, no television coverage, no panic, nothing. From this vantage point it seems as though all recognizable cultural institutions have been wiped from the landscape. But this is not like the end of Fight Club, there is no impressive crumbling and explosive spectacle of collapse, these great edifying cultural structures are simply gone...

1. All art is gone? The history of art is wiped. Forgotten. There are no more safeguarding institutions, annihilated. No collections. No Picasso's on the walls, no Henry Moore's in the garden, no stacks of beautiful paintings in the perfect climate controlled storage. No record of what was before. The canon exploded. A perfect torn void. An emancipating abyss. A deep cutting chasm of artistic potential. A vacuous black hole of innate energies collapsing into themselves and exploding in the rebirth of things authentically new. The past-tense remnant shells of art are gone, leaving behind, as it always has been the fleeting ephemeral moment of art's becomings and goings. All art is gone, with only the art remaining, blurring dissolvedly into life. Genuine artistic creation is liberated from its dominating regimes. The work, the creation of a beautiful tabula rasa landscape...

2. The climate is changing. A chaotic geo-artistry. The atmosphere is worked on. "A moment by moment awareness and exploitation of transformation in the material worked"[209] in this case the material, the geography and environment, of the earth itself. Sulfates and aerosols and other unknown particles are injected into the stratosphere deflecting solar rays and shading, and cooling, and lowering the air temperatures [210] in a strange shielding haze. The effects monitored and reacted upon, administered precipitation, and further elemental matter, generated on the spot, and introduced in an improvitisationary balancing act and creative "war against the sun."[211] The Earth temperature unnaturally resumes its natural course towards its pre-anthropocene, and simultaneously, post-anthropocene state. Cunning geoengineering mêtis designs work the environment. The atmosphere is changing. The plant life will follow, the earth, the dirt, the soil, will change. The water will change. The air will change. The economic system will change, the borders will change, everything will change. The end of the blue sky.[212] The sun will never set a sunset to ever look the same. The Earth goes on. Life goes on.

3. The humans are changing. The humans are changed. The humans are gone. The humans are obliterated. The people remain. The people change. The climate changes. The economic system changes. Science changes. Philosophy changes. Art changes.

Humanity ends. The people exist.

4. Myzeritteus Mêtis, the Alien artist, and Mary the Curator of earth stand under the yellow orange skies, together in a pseudo science fiction Hieronymus Bosch religious landscape painting. The scene combines the heavenly and the earthly; celestial spheres surround the couple as they hold a bundled newborn babe, a son, their son in the sun, over depictions of the earthly struggles that play out on the stage below. A colorful vision of rebirth.

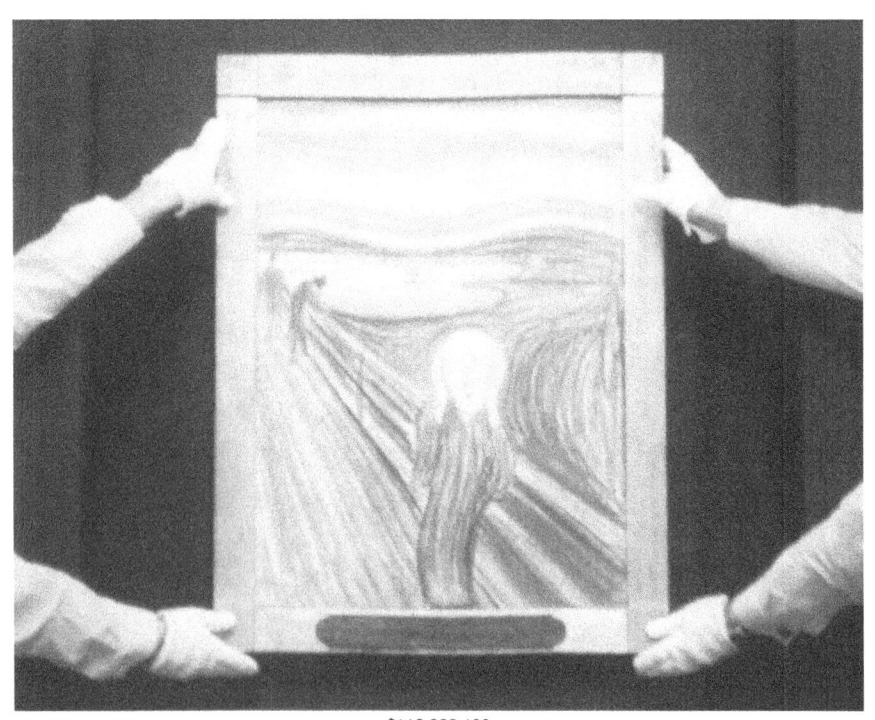

$119,922,600

*Abrupt conclusion.*
*Art works.*
*A cultural tabula rasa landscape. A new climate. A post humanity. A birth.*

## Pure Poetry & Love

# VI

## Conclusions

Whoever embraces a woman is Adam. The woman is Eve.
Everything happens for the first time.
I saw something white in the sky. They tell me it is the moon, but what can I do with a word and a mythology.
Trees frighten me a little. They are so beautiful.
The calm animals come closer so that I may tell them their names.
The books in the library have no letters. They spring forth when I open them.
Leafing through the atlas I project the shape of Sumatra.
Whoever lights a match in the dark is inventing fire.
Inside the mirror an Other waits in ambush.
Whoever looks at the ocean sees England.
Whoever utters a line of Liliencron has entered into battle.
I have dreamed Carthage and the legions that destroyed Carthage.
I have dreamed the sword and the scale.
Praised be the love wherein there is no possessor and no possessed, but both surrender.
Praised be the nightmare, which reveals to us that we the power to create hell.
Whoever goes down to a river goes down to the Ganges.
Whoever looks at an hourglass sees the dissolution of an empire.
Whoever plays with a dagger foretells the death of Caesar.
Whoever dreams is every human being.
In the desert I saw the young Sphinx, which has just been sculpted.
There is nothing else so ancient under the sun.
Everything happens for the first time, but in a way that is eternal.
Whoever reads my words is inventing them.[213]

The End

## Endnotes

1   Inspired by and with appropriations from the text of Bainbridge, David. Notes on M1, Art-Languge; The journal of Conceptual Art Vol 1, No.1, (Great Briton: May 1969).

2   Ronnel, Avital. " The Test Drive", lecture uploaded on March 12, 2008, accessed at http://www.youtube.com/watch?v=xVwoN2aLvL0.

3   Fink, Bruce. Fundamentals of Psychoanalytic Technique: A Lacanian Approach for Practitioners; Ch 1 Listening and Hearing (New York: W. W. Norton & Company; 2011) p.4.

4   Ibid, p.4-5.

5   Calum, Neill. Breaking the Text: An Introduction to Lacanian Discourse Analysis. (n.p. 2012) p.3.

6   Fink, Bruce. Fundamentals of Psychoanalytic Technique: A Lacanian Approach for Practitioners; Ch 1 Listening and Hearing, The Story Makes No Sense (Or Too Much Sense), New York: W. W. Norton & Company; 2011) p. 13.

7   This analogy is inspired by and based on: Ryan, Paul. Video Mind, Earth Mind, (New York: Peter Lang; 1992) p.408.

8   The classification of the painter is used here but it holds true to signify all the criterion of artists, sculptures, photographers, dancers, etc.

9   Ryan, Paul. Video Mind, Earth Mind, (New York: Peter Lang; 1992) p.408.

10   Barthes, Roland. "The Death of the Author". Image/Music/Text (New York: Hill and Wang, 1977) p.7.

11   Calum, Neill. Breaking the Text: An Introduction to Lacanian Discourse Analysis. (n.p. 2012) p.4.

12    Lacan, Jaques. The Four Fundamental Concepts of Psychoanalysis (New York: W.W. Norton, 1998) p.103.

13    Harrison, Charles. Conceptual Art and Painting: Further Essays on Art & Language. (London: the MIT Press; 2001) p. 172.

14    Trevatt, Tom. " Thought from the Anthropocene: The Problems of Representation" for Matter of Contradiction, 2012 accessed at http://vimeo.com/51894893.

15    From this point on the entire section of dialogue is direct quotes culled from Marcel Duchamp's paper, Duchamp, Marcel. "The Creative Act - Lecture at the Museum of Modern Art, New York, October 19, 1961." Art and Artists 1, no. 4 (1966): http://www.ubu.com/papers/duchamp_creative.html.

16    This line is the final part of the above text that has pulled directly From Duchamp's words in "The Creative Act".

17    Duchamp, Marcel. " Apropos of 'Readymades'- Lecture at the Museum of Modern Art, New York, October 19, 1961." Art and Artists 1, no. 4 (1966): http://radicalart.info/things/readymade/duchamp/text.html.

18    Beuys, Joseph, Volker Harlan, Matthew Barton and Shelley Sacks. What is Art?. London: Clairview Books, 2004. P. 14.

19    Sacks, Shelly in the foreword to; Beuys, Joseph, Volker Harlan, Matthew Barton and Shelley Sacks. What is Art?. London: Clairview Books, 2004. P.ix.

20    Ibid, p. ix, x.

21    S. Stauffer (ed.): Marcel Duchamp: Die Schriften, Vol. I. Zürich: Regenbogen-Verlag, 1981, p. 125.

22    Arturo Schwarz: The Complete Works of Marcel Duchamp (London: Thames and Hudson, 1969), p. 194.

23    McMullen, Ken. Ghost Dance. 1983. Film.

24  Zizek, Slavoj. Zizek!, Astra Taylor, Slavoj Zizek. 2005. film.

25  Huyghe, Pierre. " Pierre Huyghe: the Moment of Suspension". Domus, October 18, 2011: http://www.domusweb.it/en/art/2011/10/18/pierre-huyghe-the-moment-of-suspension.html

26  Ibid.

27  Ibid.

28  Lacan, Jacques. The Four Fundamental Concepts of Psychoanalysis (New York: W.W. Norton, 1998) p.116.

29  Calum, Neill. Breaking the Text: An Introduction to Lacanian Discourse Analysis. (n.p. 2012) p.3

30  Zizek, Slavoj. The Perverts Guide to Ideology. film, Sophie Fiennes, 2012.

31  Ibid.

32  Ibid.

33  Zizek, Slavoj. "Why Only an Atheist Can Believe", a lecture delivered at Calvin College, Michigan, on November 10, 2006. http://www.youtube.com/watch?v=MyX4JwfjoBQ&list=PLD0335B03546BFF82.

34  Ibid.

35  Ibid.

36  The following dialogue quotes directly from an interview with Raimundas Malašauskas and Chris Fitzpatrick, originally published in 2009 on www.picpuspicpus.blogspot.com. accessed at http://www.pcah.us/blog/entry/excerpts-from-an-interview-with-raimundas-malasauskas/.

37  Ibid.

38   Lifshitz, Mikhail. The Philosophy of Art of Karl Marx, (London: Pluto Press, 1976) p. 116.

39   Filliou, Robert. Teaching and Learning as Performing Arts, (New York: Verlag Gebr. Koenig, 1970) p. 170.

40   Beuys, Joseph interviewed in Filliou, Robert. Teaching and Learning as Performing Arts, (New York: Verlag Gebr. Koenig, 1970) p. 171.

41   Beuys, Joseph, Volker Harlan, Matthew Barton and Shelley Sacks. What is Art? London: Clairview Books, 2004. P. 26.

42   Ibid.

43   Ibid.

44   Ibid, p.27.

45   Ibid.

46   Ibid.

47   Ibid.

48   The following dialogue is taken, in most cases, word for word from: Kaprow, Allan. "Art Which Can't Be Art". Originally published in Essays on the Blurring of Life With Art, by Kaprow, Allan and Jeff Kelly. Berkeley: University of California Press, 1993.

49   O'Doherty, Brian. Inside the White Cube: The Ideology of the Gallery Space, (Santa Monica: The Lapis Press, 1976) p 80.

50   Ibid.

51   Ibid.

52   Brecht, Bertolt. "The Threepenny Lawsuit", originally printed in German as 'Der Dreigroschenprozess', Schriften zur Literatur und Kunst /, Gesammelte Werke 18, Frankfurt am Main: Suhrkamp.

Translated to English by John Frow here; http://humanities.curtin.edu.au/schools/MCCA/ccs/AJCS_journal/J2V1/J2V1Film,%20Commodity%20Production%20and%20the%20Law%20-%20Brecht's%20Sociological%20Experiment.htm.

53   Ibid.

54   Brecht, Bertolt in Walter Benjamin's footnote in The Work of Art in the Age of Mechanical Reproduction. London: Penguin Books Ltd, 2008. P.43.

55   Brecht, Bertolt. "The Threepenny Lawsuit", originally printed in German as 'Der Dreigroschenprozess', Schriften zur Literatur und Kunst /, Gesammelte Werke 18, Frankfurt am Main: Suhrkamp. Translated to English by John Frow here; http://humanities.curtin.edu.au/schools/MCCA/ccs/AJCS_journal/J2V1/J2V1Film,%20Commodity%20Production%20and%20the%20Law%20-%20Brecht's%20Sociological%20Experiment.htm.

56   Brecht, Bertolt in Walter Benjamin's footnote in The Work of Art in the Age of Mechanical Reproduction. London: Penguin Books Ltd, 2008. P.43

57   Brecht, Bertolt. "The Threepenny Lawsuit", originally printed in German as 'Der Dreigroschenprozess', Schriften zur Literatur und Kunst /, Gesammelte Werke 18, Frankfurt am Main: Suhrkamp. Translated to English by John Frow here; http://humanities.curtin.edu.au/schools/MCCA/ccs/AJCS_journal/J2V1/J2V1Film,%20Commodity%20Production%20and%20the%20Law%20-%20Brecht's%20Sociological%20Experiment.htm.

58   O'Doherty, Brian. Inside the White Cube: The Ideology of the Gallery Space, (Santa Monica: The Lapis Press, 1976) p 81.

59   Ibid.

60   Ibid.

61   Ibid.

62   Ibid, p.91.

63   Doser, Michael, Art, Poetry, and Particle Physics. Ken McMullen, and John Berger. 2004, film.

64   Ibid.

65   Groys, Boris, "Comrades of Time", E-Flux Journal, no. 11 (December 2009) (www.e-flux.com).

66   De Maria, Walter. "Meaningless Work", statement, March, 1960. "Fluxus Debris"; http://www.artnotart.com/fluxus/wdemaria-meaninglesswork.html.

67   Ibid.

68   In conversation with Michael Walton and Victoria Crowe, the artists who created the Higgs portrait commissioned by the Scottish National Portrait Gallery, Edinbrugh.

69   Jonckheere, Lieven. "Psychoanalysis and Psychotherapy: the Irony of a Relationship" at http://users.skynet.be/gpp-congres/enlieven.htm.

70   Boyle, Robert. Works of the Honorable Robert Boyle. London: Kessinger Publishing. (2003) [1744], p. 740.

71   Barad, Karen. "What Is the Measure of Nothingness? Infinity, Virtuality, Justice ", in The Book of Books: dOCUMENTA (13) Catalog 1/3 (Hatje Cantz Publishers, 2012) p. 646.

72   Barad, Karen. "What Is the Measure of Nothingness? Infinity, Virtuality, Justice ", in The Book of Books: dOCUMENTA (13) Catalog 1/3 (Hatje Cantz Publishers, 2012) p. 648.

73   Caillois, Roger. The Necessity of the Mind (Venice, California: Lapis Press; 1990) p.44-45.

74   De Vries, Herman. "un langage ouvert. An open language. Eine offene sprache," introductory manifesto to On Language,

Subvers 8, 1972, quoted by Anne Moeglin-Delcroix in "Neither Word Nor Image: Blank Books" in Voids: A Retrospective, Centre Pompidou catalogue. (Zurich: JRP/Ringier; 2009), p. 397.

75   Barad, Karen. "What Is the Measure of Nothingness? Infinity, Virtuality, Justice ", in The Book of Books: dOCUMENTA (13) Catalog 1/3 (Hatje Cantz Publishers, 2012) p. 648.

76   Grünbein, Durs. "Dream Index", introduction by Micheal Eskin in The Book of Books: dOCUMENTA (13) Catalog 1/3 (Hatje Cantz Publishers, 2012) p. 410.

77   Hayman, David. "My Dinner With Jacques" at http://www.lacan.com/frameXI5.htm.

78   Ibid.

79   Joyce, James. Finnegans Wake. Ed. by Robbert-Jan Henkes, Erik Bindervoet and Finn Fordham (Oxford: Oxford University Press; 1993) p. 304.

80   Tindall, William York. A Reader's Guide to James Joyce. (New York: First Syracuse University Press Edition; 1995), p. 263.

81   The following dialogue is taken from Calum, Neill. Breaking the Text: An Introduction to Lacanian Discourse Analysis. (n.p. 2012) p.5-9.

82   End of citation, ibid.

83   Giraud, Fabien. "The Suffocation of Birds", Script for The Matter of Contradiction – War against the Sun. London. 2013. P.1.

84   Ibid.

85   Ibid.

86   Ibid.

87   Ibid, p.2.

88   Ibid.

89   Grosz, Elizabeth. The introduction from Becomings: Explorations in Time, Memory and Futures (Ithaca: Cornell University Press, 1999) p. 3.

90   Ibid.

91   Brassier, Ray. Nihil Unbound: Enlightenment and Extinction. (New York: Palgrave Macmillan; 2007), p. xi.

92   Williams, Alex. "At the Dawn of the Anthropocene" presented at The Matter of Contradiction: War Against the Sun. 2013, accessed at:  http://vimeo.com/67001709.

93   Giraud, Fabien. "The Suffocation of Birds", Script for The Matter of Contradiction – War against the Sun. London. 2013. P.3.

94   Ibid.

95   Ibid, p.4.

96   Ibid.

97   Ibid.

98   Ibid

99   For a full account of this research:  La Sculpture du Vivant. Le Suicide Cellulaire ou la Mort Créatrice. Jean Claude Ameisen. Seuil: 1999.

100   Giraud, Fabien. "The Suffocation of Birds", Script for The Matter of Contradiction – War against the Sun. London. 2013. p.5.

101   Ibid, p.5,6.

102   Ibid, p.6.

103   Ibid.

104   Ibid.

105   Ibid.

106   Ibid.

107   Williams, Alex. "At the Dawn of the Anthropocene" presented at The Matter of Contradiction: War Against the Sun. 2013, accessed at: http://vimeo.com/67001709.

108   "Gravity" Alfonso Cuarón. 2013. Film.

109   Shannon, Matthew. The following from conversational analysis of the film, October, 2013.

110   http://hrsbstaff.ednet.ns.ca/waymac/African%20Canadian%20Studies/Unit%202%20About%20Africa/00human_evolution.htm.

111   Williams, Alex. "Taking the Wrong Turn" for the Planetary Politics After the Human panel, millennium conference, 2012, p.8

112   Williams, Alex. "At the Dawn of the Anthropocene" presented at The Matter of Contradiction: War Against the Sun. 2013, accessed at: http://vimeo.com/67001709, title.

113   Bainbridge, David. "Notes on M1", Reprinted from Art-Language, Vol. 1, no.1 (1969) accessed at http://www.ubu.com/papers/bainbridge_m1.html.

114   Steyerl, Hito. "In Free Fall: A Thought Experiment On Vertical Perspective", e-flux journal, no. 24 (April 2011) at http://www.e-flux.com/journal/in-free-fall-a-thought-experiment-on-vertical-perspective/.

115   Trevatt, Tom. " Introduction to Ungrounding the Object" for Matter of Contradiction, 2012 accessed at http://vimeo.com/51894893.

116 Trevatt, Tom. " Thought from the Anthropocene: The Problems of Representation" for Matter of Contradiction, 2012 accessed at http://vimeo.com/51894893.

117 Ibid.

118 Fink, Bruce. Fundamentals of Psychoanalytic Technique: A Lacanian Approach for Practitioners, (New York: W. W. Norton & Company; 2011) p. 10.

119 Barlog, James in Chasing Ice. Jeff Orlowski, 2012. Film.

120 Williams, Alex. "At the Dawn of the Anthropocene" presented at The Matter of Contradiction: War Against the Sun. 2013, accessed at: http://vimeo.com/67001709.

121 Ibid.

122 Trevatt, Tom. " Thought from the Anthropocene: The Problems of Representation" for Matter of Contradiction, 2012 accessed at http://vimeo.com/51894893.

123 Austin, Michael. "The Question of Lacanian Ontology: Badiou and Zizek as response to Seminar XI", International Journal of Zizek Studies, volume 5, number 2, p.7 at http://zizekstudies.org/index.php/ijzs/article/viewFile/335/400.

124 Lacan, Jacques. Écrits, trans. Bruce Fink (New York: W.W. Norton & Co; 2006) p.516.

125 Austin, Michael. "The Question of Lacanian Ontology: Badiou and Zizek as response to Seminar XI", International Journal of Zizek Studies, volume 5, number 2, p.7 at http://zizekstudies.org/index.php/ijzs/article/viewFile/335/400.

126 Ibid.

127 Lacan, Jacques. Écrits, trans. Bruce Fink (New York: W.W. Norton & Co; 2006) p.517.

128   Zizek, Slavoj. The Perverts Guide to Ideology. film, Sophie Fiennes, 2012.

129   Ibid.

130   Benjamin, Walter.

131   Zizek, Slavoj. The Perverts Guide to Ideology. film, Sophie Fiennes, 2012.

132   Ibid.

133   Moran, Joe. "Benjamin and Boredom", Critical Quarterly, vol. 45, nos. 1–2. p.12.

134   Zizek, Slavoj. The Perverts Guide to Ideology. film, Sophie Fiennes, 2012.

135   Moran, Joe. "Benjamin and Boredom", Critical Quarterly, vol. 45, nos. 1–2. p.3.

136   Benjamin, Walter. The Arcades Project. Trans. Howard Eiland and Kevin McLaughlin. Cambridge, Mass: The Belknap Press of Harvard University Press, 2002. p.391.

137   Benjamin, Walter. The Arcades Project. Trans. Howard Eiland and Kevin McLaughlin. Cambridge, Mass: The Belknap Press of Harvard University Press, 2002. P.105

138   Nietzsche, Gesammelte Werke, vol. 19 (The Will to Power, hook 4), p, 370. Quoted in The Arcades Project by Walter Benjamin, p.115.

139   Moran, Joe. "Benjamin and Boredom", Critical Quarterly, vol. 45, nos. 1–2. p.1.

140   Ibid, p.13.

141    Benjamin, Walter. The Arcades Project. Trans. Howard Eiland and Kevin McLaughlin. Cambridge, Mass: The Belknap Press of Harvard University Press, 2002. p.106.

142    Ibid, p.105.

143    Ibid, p.106.

144    Ibid, p.108.

145    Grünbein, Durs. "Dream Index", introduction by Micheal Eskin in The Book of Books: dOCUMENTA (13) Catalog 1/3 (Hatje Cantz Publishers, 2012) p. 410.

146    Zizek, Slavoj. The Perverts Guide to Ideology. film, Sophie Fiennes, 2012.

147    Ibid.

148    Hoddis, Jakob van. From Weltende, translated and quoted in The Arcades Project by Walter Benjamin, p. 101.

149    Zizek, Slavoj. Tarrying with the Negative: Kant, Hegel, and the Critique of Ideology (Durham: Duke University Press: 1993), p.1.

150    Ibid.

151    Ibid.

152    Zizek, Slavoj. The Perverts Guide to Ideology. film, Sophie Fiennes, 2012.

153    Ibid.

154    Ibid

155    Ibid

156    Ibid.

157 Trevatt, Tom. " Thought from the Anthropocene: The Problems of Representation" for Matter of Contradiction, 2012 accessed at http://vimeo.com/51894893.

158 Ibid.

159 Giraud, Fabien. "Introduction to Ungrounding the Object", Matters of Contradiction conference, December 2011. Accessed at http://vimeo.com/51894893.

160 Bratton, Benjamin. "Some Trace Effects of the Post-Anthropocene: On Accelerationist Geopolitical Aesthetics", e-flux journal #46 06/2013 accessed at http://www.e-flux.com/journal/some-trace-effects-of-the-post-anthropocene-on-accelerationist-geopolitical-aesthetics/#_ftn9.

161 Bryant, Levi. "Onticology: A Manifesto for Object-Oriented Ontology, Part 1," Larval Subjects, accessed at http://larvalsubjects.wordpress.com/2010/01/12/object-oriented-ontology-a-manifesto-part-i/.

162 Harman, Graham. Tool-Being: Heidegger and the Metaphysics of Objects. Peru, Illinois: Open Court, 2002. p. 16.

163 Harman, Graham. Guerrilla Metaphysics: Phenomenology and the Carpentry of Things. Peru, Illinois: Open Court, 2005. p. 1.

164 Segall, Matthew David. "Cosmos, Anthropos, and Theos in Harman, Teilhard, and Whitehead". Footnotes to Plato. accessed at http://footnotes2plato.com/2011/07/12/cosmos-anthropos-and-theos-in-harman-teilhard-and-whitehead/.

165 Bryant, Levi; Harman, Graham; Srnicek, Nick. The Speculative Turn: Continental Materialism and Realism. Melbourne, Australia: re.press, 2011. p. 268.

166 Trevatt, Tom. " Thought from the Anthropocene: The Problems of Representation" for Matter of Contradiction, 2012 accessed at http://vimeo.com/51894893.

167   Ibid

168   Ibid.

169   Negarestani, Reza. Cyclonopedia: Complicity with Anonymous Materials. Melbourne, Australia: re.press, 2008. p.197.

170   Trevatt, Tom. " Thought from the Anthropocene: The Problems of Representation" for Matter of Contradiction, 2012 accessed at http://vimeo.com/51894893.

171   Giraud, Fabien. "Introduction to Ungrounding the Object", Matters of Contradiction conference, December 2011. Accessed at http://vimeo.com/51894893.

172   Ibid.

173   Williams, Alex. "At the Dawn of the Anthropocene" presented at The Matter of Contradiction: War Against the Sun. 2013, accessed at:  http://vimeo.com/67001709.

174   Ibid.

175   Ibid.

176   Gormley, Antony and Michael Newman. "Still Being: A Conversation about Time in Art" at the Queen Elizabeth Hall, Southbank Centre, London, June, 2012.

177   Bratton, Benjamin. "Some Trace Effects of the Post-Anthropocene: On Accelerationist Geopolitical Aesthetics", e-flux journal #46 06/2013 accessed at http://www.e-flux.com/journal/some-trace-effects-of-the-post-anthropocene-on-accelerationist-geopolitical-aesthetics/#_ftn9.

178   Ibid.

179   Segall, Matthew David. "Cosmos, Anthropos, and Theos in Harman, Teilhard, and Whitehead". Footnotes to Plato. accessed at http://footnotes2plato.com/2011/07/12/cosmos-anthropos-and-theos-in-harman-teilhard-and-whitehead/.

180   Bratton, Benjamin. "Some Trace Effects of the Post-Anthropocene: On Accelerationist Geopolitical Aesthetics", e-flux journal #46 06/2013 accessed at http://www.e-flux.com/journal/some-trace-effects-of-the-post-anthropocene-on-accelerationist-geopolitical-aesthetics/#_ftn9.

181   Segall, Matthew David. "Cosmos, Anthropos, and Theos in Harman, Teilhard, and Whitehead". Footnotes to Plato. accessed at http://footnotes2plato.com/2011/07/12/cosmos-anthropos-and-theos-in-harman-teilhard-and-whitehead/.

182   Williams, Alex. "At the Dawn of the Anthropocene" presented at The Matter of Contradiction: War Against the Sun. 2013, accessed at: http://vimeo.com/67001709.

183   Singleton, Benedict. "Maximum Jailbreak", e-flux journal #46 06/2013 accessed at http://www.e-flux.com/journal/maximum-jailbreak/.

184   Williams, Alex. "At the Dawn of the Anthropocene" presented at The Matter of Contradiction: War Against the Sun. 2013, accessed at: http://vimeo.com/67001709.

185   Detienne, Marcel and Jean Pierre Vernant. Cunning Intelligence in Greek Culture and Society (Hassocks: Harvester Press, 1978).

186   Williams, Alex. "Escape Velocities", e-flux journal #46 06/2013 accessed at http://www.e-flux.com/journal/escape-velocities/#_ftn21.

187   Williams, Alex. "At the Dawn of the Anthropocene" presented at The Matter of Contradiction: War Against the Sun. 2013, accessed at: http://vimeo.com/67001709.

188   Singleton, Benedict. "Maximum Jailbreak", e-flux journal #46 06/2013 accessed at http://www.e-flux.com/journal/maximum-jailbreak/.

189   Detienne, Marcel and Jean Pierre Vernant. Cunning Intelligence in Greek Culture and Society (Hassocks: Harvester Press, 1978), p.6.

190   Detienne, Marcel and Jean Pierre Vernant. Cunning Intelligence in Greek Culture and Society (Hassocks: Harvester Press, 1978).

191   Ibid.

192   Ibid.

193   Giraud, Fabien. "Introduction to Ungrounding the Object", Matters of Contradiction conference, December 2011. Accessed at http://vimeo.com/51894893.

194   Williams, Alex. "Escape Velocities", e-flux journal #46 06/2013 accessed at http://www.e-flux.com/journal/escape-velocities/#_ftn21.

195   Detienne, Marcel and Jean Pierre Vernant. Cunning Intelligence in Greek Culture and Society (Hassocks: Harvester Press, 1978).

196   Rees, Martin. "How Post-Humans Could Colonise Other Worlds", The Telegraph. 03/05/2103 accessed at http://www.telegraph.co.uk/culture/film/film-news/10034310/Sir-Martin-Rees-How-post-humans-could-colonise-other-worlds.html.

197   Singleton, Benedict. "Maximum Jailbreak", e-flux journal #46 06/2013 accessed at http://www.e-flux.com/journal/maximum-jailbreak/.

198   Chamayou, Manhunts: A Philosophical History (Princeton, NJ: Princeton University Press, 2012), p.70.

199   Singleton, Benedict. "Maximum Jailbreak", e-flux journal #46 06/2013 accessed at http://www.e-flux.com/journal/maximum-jailbreak/.

200   Ibid.

201   Williams, Alex. "At the Dawn of the Anthropocene" presented at The Matter of Contradiction: War Against the Sun. 2013, accessed at: http://vimeo.com/67001709

202   Brassier, Ray. Nihil Unbound: Enlightenment and Extinction. (New York: Palgrave Macmillian, 2007), p.xi.

203   Fedorov, Nikolai. quoted in Singleton, Benedict. "Maximum Jailbreak", e-flux journal #46 06/2013 accessed at http://www.e-flux.com/journal/maximum-jailbreak/.

204   Brassier, Ray. Nihil Unbound: Enlightenment and Extinction. (New York: Palgrave Macmillian, 2007), p.xi.

205   Bratton, Benjamin. "Some Trace Effects of the Post-Anthropocene: On Accelerationist Geopolitical Aesthetics", e-flux journal #46 06/2013 accessed at http://www.e-flux.com/journal/some-trace-effects-of-the-post-anthropocene-on-accelerationist-geopolitical-aesthetics/#_ftn9.

206   Ibid.

207   This passage is informed by Bruce Fink in Fundamentals of Psychoanalytic Technique: A Lacanian Approach for Practitioners; Ch.10 Treating Psychosis (New York: W. W. Norton & Company; 2011), p.231-262.

208   Filliou, Robert. Teaching and Learning as Performance Arts. (Cologne/New York: Verlag Gebr. König; 1970).

209   Williams, Alex. "At the Dawn of the Anthropocene" presented at The Matter of Contradiction: War Against the Sun. 2013, accessed at: http://vimeo.com/67001709.

210   Matter of Contradiction collective, Introduction to "War against the Sun" conference March 2133, London.

211   Ibid.

212   Hodges, Jim. "Geoengineering: Why or Why Not?" The Researcher News, Langley Research Center, NASA, Hampton Virginia accessed at http://www.nasa.gov/centers/langley/news/researchernews/rn_robockfeature.html

213   Borges, Jorge Luis. "Happiness" as read by John Berger in Art, Poetry and Particle Physics, Ken McMullen, and John Berger. 2004, film.

# Bibliography

Allen, Greg. The Deposition of Richard Prince in the Case of Cariou V. Prnice Et Al. Lithuania: Bookhorse, 2012.

Anastas, Ayreen and Rene Gabri. "Two is Not a Number". Published in dOCUMENTA (13) Catalog 1/3: Book of Books, by Christov-Bakargiev, Carolyn and Chus Martínez. Hatje Cantz, 2012.

"Art, Poetry and Particle Physics". Ken McMullen, and John Berger. 2004. film.

"Art Safari - Relational Art; is it an Ism?." Ben Lewis. 2002. video. Arthistoryunstuffed.com. "Conceptual Art « Art as Idea - Idea as Art." 2012. http://www.arthistoryunstuffed.com/conceptual-art/ (accessed 14 Aug 2013).

Badiou, Alain and Peter Bush. In Praise of Love. New York: The New Press, 2012.

Bainbridge, David. "Notes on M1." Art-Languge; The Journal of Conceptual Art 1, no. 1 (1969): http://www.ubu.com/papers/bainbridge_m1.html.

Barthes, Roland. "The Death of the Author." Image / Music / Text. Trans. Stephen Heath. New York: Hill and Wang, 1977. 142-7.

Bateson, Gregory. "The Cybernetics of "Self": A Theory of Alcoholism." Psychiatry 34, no. 1 (1972).

Benjamin, Walter. The Arcades Project. Trans. Howard Eiland and Kevin McLaughlin. Cambridge, Mass: The Belknap Press of Harvard University Press, 2002.

Benjamin, Walter. The Work of Art in the Age of Mechanical Reproduction. London: Penguin Books Ltd, 2008.

Benkinmont.com. "Ben Kinmont Projects and Catalytic texts." n.d.. http://www.benkinmont.com/ (accessed 14 Dec 2012).

Beuys, Joseph, Volker Harlan, Matthew Barton and Shelley Sacks. What is Art?. London: Clairview Books, 2004.

Bion, Wilfred R. Experience in Groups. London: Routledge, 1961.
Bishop, Claire. Participation. London: Whitechapel, 2006.

Bishop, Claire. Artificial Hells. London: Verso Books, 2012.

Boal, Augusto. The Rainbow of Desire. London: Routledge, 1995.
Borges, Jorge Luis, translated by Andrew Hurley . Collected Fictions. London: Penguin Books, 1999.

Bourriaud, Nicolas. Relational Aesthetics. [Paris]: Les Presses du Réel, 2002.

Brecht, Bertolt. 'Der Dreigroschenprozess', Schriften zur Literatur und Kunst /, Gesammelte Werke 18, Frankfurt am Main: Suhrkamp
Brecht, Bertolt. The Messingkauf Dialogues. London: Methuen, 1965.

Bruderlein, Markus. "Work on the White Cube." Taking Place Zurich: Kunsthalle Zurich/Copenhagen: Danish Contemorary Art Foundation/Ostfildern-Ruit: Hatje Cantz, (2001).

Burgin, Victor. "Situational Aesthetics." Studio International 178, no. 915 (1969).

Caillois, Roger. The Necessity of the Mind (Venice, California: Lapis Press; 1990).

Calum, Neill. Breaking the Text: An Introduction to Lacanian Discourse Analysis. Theory and Psychology, n.p.

"Chasing Ice." Jeff Orlowski with James Barlog, 2012. Film.

"Coming Apart." Milton Moses Ginsberg. 1969. Film.

Danto, Arthur C. What Art Is. New Haven and London: Yale University Press, 2013.

Danto, Arthur. "The Artworld." Journal of Philosophy 61, no. 19 (1964): 571-584.

Derrida, Jacques. Given Time. Chicago: University of Chicago Press, 1992.

Derrida, Jacques. Resistances of Psychoanalysis. Stanford, Calif.: Stanford University Press, 1998.

Dickie, George. Art and the Aesthetic: An Institutional Analysis. New York: Cornell University Press, 1974.

Doherty, Claire. Situation. London: Whitechapel Gallery, 2009.
Duchamp, Marcel. "Apropos of 'Readymades'- Lecture at the Museum of Modern Art, New York, October 19, 1961." Art and Artists 1, no. 4 (1966): http://radicalart.info/things/readymade/duchamp/text.html.

Duchamp, Marcel. "The Creative Act - Lecture at the Museum of Modern Art, New York, October 19, 1961." Art and Artists 1, no. 4 (1966): http://www.ubu.com/papers/duchamp_creative.html.

Etchegoyen, R. Horacio. The Fundamentals of Psychoanalytic Technique. London: Karnac Books, 2005.

Filliou, Robert. Teaching and Learning as Performing Arts, New York: Verlag Gebr. Koenig, 1970.

Fink, Bruce. Fundamentals of Psychoanalytic Technique: A Lacanian Approach for Practitioners. New York: W.W. Norton, 2007.

Frow, John. "Film, Commodity Production and the Law: Brecht's Sociological Experiment" at http://humanities.curtin.edu.au/schools/MCCA/ccs/AJCS_journal/J2V1/J2V1Film,%20Commodity%20Production%20and%20the%20Law%20-%20Brecht's%20Sociological%20Experiment.htm.

Freud, Sigmund. Totem and Taboo. New York: Norton, 1952.

"Ghost Dance." Ken McMullen. 1982. Film.

Giraud, Fabien. "The Suffocation of Birds", Script for The Matter of Contradiction – War Against the Sun. London. 2013.

Goldsmith, Kenneth. Uncreative Writing. New York: Colombia University Press, 2011.

"Gravity", Alfonso Cuarón. 2013. Film.

Groys, Boris. "Comrades of Time", E-Flux Journal, no. 11(December 2009): http://www.e-flux.com).

Groys, Boris. "The Weak Universalism." E-Flux 15, no. 04 (2010): http://www.e-flux.com/journal/the-weak-universalism/.

Harrison, Charles. Conceptual Art and Painting: Further Essays on Art & Language. London: The MIT Press, 2001.

Holler, Carsten. "The Baudouin/Boudewijn Experiment. A Deliberate, Non-Fatalistic Large Scale Group Experiment in Deviation". Published in Participation, by Bishop, Claire. London: Whitechapel, 2006.

Huebler, Douglas. Statement - A group exhibition of Robert Barry, Douglas Huebler, Joseph Kosuth, and Lawrence Weiner in which the exhibition was the guide to the catologue. Seth Siegelaub. 1969.

Huyghe, Pierre and Allard van Hoorn " Pierre Huyghe: the Moment of Suspension". Domus, October 18, 2011: http://www.domusweb.it/en/art/2011/10/18/pierre-huyghe-the-moment-of-suspension.html.

Irwin, Robert and Lawrence Weschler. Being and Circumstance. Larkspur Landing, Calif.: Lapis Press in conjunction with the Pace Gallery and the San Francisco Museum of Modern Art, 1985.

Iversen, Margaret. Chance. London: Whitechapel, 2010.

Kant, Immanuel and Werner S Pluhar. Critique of Judgment. Indianapolis, Ind.: Hackett Pub. Co., 1987.

Kaprow, Allan. "Art Which Can't Be Art". Originally published in Essays on the Blurring of Life With Art, by Kaprow, Allan and Jeff Kelly. Berkeley: University of California Press, 1993.

Kaprow, Allan. "The Education of the Un-Artist". Originally published in Essays on the Blurring of Life With Art, by Kaprow, Allan and Jeff Keley. Berkeley: University of California Press, 1993.

Kaprow, Allan. "Untitled Manifesto". Originally published in Essays on the Blurring of Life With Art, by Kaprow, Allan. Berkeley: University of California Press, 1993.

Kelly, Mike. The Mike Kelly Retrospective. The Stedelijk Museum. Amsterdam. 2012.

Kimmelman, Michael. The Accidental Masterpiece. New York: Penguin Press, 2005.

Kinmont, Ben. Materialization of Life into Alternative Economies. 2011.

Kosuth, Joseph. Art After Philosophy and After. Cambridge, Mass.: MIT Press, 1991.

Krause, Chris. I Love Dick. Los Angeles, CA.: Semiotext(e), 2007.
Lacan, Jacques, Héloïse Fink and Bruce Fink. Ecrits. New York: W.W. Norton & Co., 2006.

Lacan, Jacques. "From Rome '53 to Rome '67: Psychoanalysis. Reason for a Defeat." In Conference at the "Magistero" of the University of Rome, Paris: Éditions du Seuil, 1967.

Latour, Bruno and Steve Woolgar. Laboratory Life. Princeton, N.J.: Princeton University Press, 1986.

Malašauskas, Raismundas and Chris Fitzpatrick. "Excerpts from an Interview With Raimundas Malasaukas". Originally published in 2009 on www.picpuspicpus.blogspot.com. Accessed at http://www.pcah.us/blog/entry/excerpts-from-an-interview-with-raimundas-malasauskas/.

"My Dinner With Andre." Louis Maille. 1981. Film.

Nietzsche, Friedrich Wilhelm, Keith Ansell-Pearson and Carol Diethe. On the Genealogy of Morality. New York: Cambridge University Press, 1994.

O'Doherty, Brian. Inside the White Cube: The Ideology of the Gallery Space. Santa Monica: The Lapis Press, 1976.

Owens, Craig and Scott Stewart Bryson. Beyond Recognition: Representation, Power and Culture. Berkeley: University of California Press, 1992.

Rendell, Jane. "Site-Writing". Published in Situation, by Doherty, Claire. London: Whitechapel, 2009.

Ryan, Paul. "Paul Ryan - 12-18-95 Air date - Conversations with Harold Hudson Channer." 1997. http://www.youtube.com/watch?v=4QtgvLEZJOw (accessed 22 Oct 2012).

Ryan, Paul. Video Mind, Earth Mind. New York: P. Lang, 1993. "Symbiopsychotaxiplasm." William Greaves. 1968. Film.

"The Perverts Guide to Cinema." Sophie Fiennes, Slavoj Zizek. 2006. Film.

"The Perverts Guide to Ideology." Sophie Fiennes, Slavoj Zizek. 2012. Film.

Tiravaija, Rirkrit. "No Ghosts in the Wall". Published in Participation, by Bishop, Claire. London: Whitechapel, 2006.

Vallos, Fabien. "Economy and the Gift." In Sandberg Series, 2012.

Žižek, Slavoj. Tarrying with the Negative. Durham: Duke University Press, 1993.

Zizek, Slavoj. "Why Only an Atheist Can Believe," a lecture delivered at Calvin College, Michigan, on November 10, 2006. http://www.youtube.com/watch?v=MyX4JwfjoBQ&list=PLD0335B03546BFF82.

"Zizek!". Astra Taylor, Slavoj Zizek. 2005. Film.

Design Concept: Foundation and Trust
(thefoundationandtrust.org)

www.ingramcontent.com/pod-product-compliance
Lightning Source LLC
Chambersburg PA
CBHW060832170526
45158CB00001B/142